A Kingston ALBUM

A Kingston ALBUM

Glimpses of the Way We Were

Marion Van de Wetering

HOUNSLOW PRESS
A MEMBER OF THE DUNDURN GROUP
TORONTO · OXFORD

Hounslow Press
A Member of the Dundurn Group

Publisher: Anthony Hawke
Editor: Barry Jowett
Design: Scott Reid
Printer: Transcontinental Printing Inc.

Canadian Cataloguing in Publication Data
Van de Wetering, Marion
A Kingston album: glimpses of the way we were

ISBN 0-88882-200-6
1. Kingston (Ont.) — History — Pictorial works. I. Title.

FC3099.K5V36 1999 971.3'72'00222 C98-931586-X F1059.5.K5V36 1999

1 2 3 4 5 03 02 01 00 99

THE CANADA COUNCIL | LE CONSEIL DES ARTS
FOR THE ARTS | DU CANADA
SINCE 1957 DEPUIS 1957

We acknowledge the support of the **Canada Council for the Arts** for our publishing program. We also acknowledge the support of the **Ontario Arts Council** and the **Book Publishing Industry Development Program** of the **Department of Canadian Heritage.**

Printed and bound in Canada.

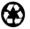

Printed on recycled paper.

Hounslow Press	Hounslow Press	Hounslow Press
8 Market Street	73 Lime Walk	2250 Military Road
Suite 200	Headington, Oxford,	Tonawanda NY
Toronto, Canada	England	U.S.A. 14150
M5E 1M6	OX3 7AD	

Acknowledgements

This book could never have been written without the help of many very understanding people. First, as always, come my family, who are ever patient, kind, and understanding of the last minute mix-ups and emergencies which inevitably crop up. Their support, from meals and child care to computer time and critiques, has been greatly appreciated. My sincere thanks in this regard go to Ria Van Holten, Jan Van de Wetering, Marie-Francoise Guédon, Anne-Marie, Reine and Joelle Guédon, Sven Van de Wetering, and Birgit Gießer.

Thanks also go to those who have helped steer me in my quest to find obscure sources and beautiful photos. For these professionals, no problem is too insignificant to listen to, or too great to be overcome. Many thanks in this regard go to all the staff at the National Archives of Canada, The National Library of Canada, Queen's University Archives, and the Archives of Ontario.

In a similar vein, this work would be truly impossible without the work of those who've gone before, who have painstakingly researched material for papers presented at historical society functions, or history books and pamphlets on their areas of interest and expertise. Thanks also to all the people who have donated their historic photos to archives, without whom this book would be merely a collection of stories.* Every effort has been made to trace the origin of photos used throughout, and any omissions in this regard are solely my fault.

Tony Hawke, publisher at Hounslow deserves special thanks, both for giving me a shot the first time around, and for sticking with me the second time. In addition, Barry Jowett has, once again, done an outstanding job of editing my rough draft.

Kaye Fulton also merits special recognition here, both for her fervent enthusiasm for *An Ottawa Album*, and for loaning me some of the rare gems from her personal library as source material for *A Kingston Album*.

Finally and most of all, this work would never have even begun without the love and support of my husband, Mark, and daughter, Maia, who go cheerfully on with their days no matter what crisis I happen to come up with.

* Special thanks in this regard go to Rob Buttle and Irene Mooney, for allowing me to use their photos, and to Charles Panet, for pointing me in the right direction.

For my family, who have to put up with me,
and for my friends, who do anyway.

Introduction

Kingston is a study in contrasts: the British military base with French origins, the quick rise to prominence followed by the languid decline, the centre of a shipping system in the age of air travel.

It would be easy to say that decisions not of Kingston's making have forced it to become less than it could have been. The city's rise to prominence as the principal point of transshipment on the Great Lakes, where cargoes going inland had to be transferred from small bateaux to the great sailing ships which plied the lakes, was followed by a gradual decline as market forces and improvements in the St. Lawrence Seaway dictated.

The city's initial position as one of the most important fortifications in the British colonies was later undermined as troops were recalled with the advent of Confederation. Similarly, Kingston's dream of retaining its position as capital of a united Canada fell by the wayside, a casualty of political expediency.

And yet, there is something about the city, something rare and beautiful, which captivates visitors, leaving them spellbound.

Perhaps it is that sense of history, so often paved over or subdivided into condos in other cities, that lends Kingston its particular charm. Perhaps it is the fact that its people have "beaten their swords into ploughshares" by turning their military installations, such as Fort Henry and Murney Tower, into museums, allowing the uninitiated a glimpse of the glory days of the British Empire. Perhaps it is the sense of living history – evident in the fact that so many of the surnames of Kingston's original citizens, like Grass and Richardson, still survive there today – that makes Kingston special.

Or perhaps it is the sense that Kingston has continued to build according to its own vision of its potential that has led it to prosper despite its misfortunes. The founding of Queen's College (later Queen's University) and the Royal Military College were decisions that have continued to profit the city in innumerable ways. The vision of the city council that built City Hall has finally been vindicated, as the structure is one of the most striking of its kind in the land. And, although the many penal institutions in the immediate vicinity lend Kingston a somewhat notorious air, there is no doubt that these facilities lend an aura of stability to the community.

Despite Kingston's trials, the unmistakable vitality is still there. It's there in the way those who were raised there and moved away long to return. It's there in the passion with which those who come and stay speak of their adopted home. And it's there in the sense of connectedness citizens feel with their past – and their future.

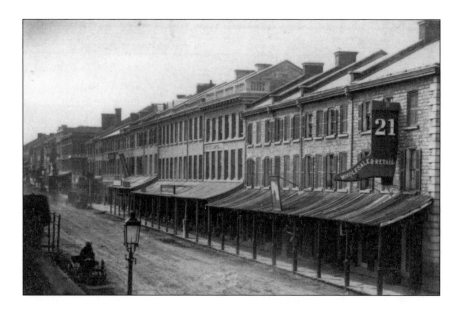

St. John's Street, c. 1860s.
*National Archives of Canada #PA-62177. Rifle
Brigade collection.*

King Street, c. 1860s.
National Archives of Canada #PA-62172. Rifle Brigade collection.

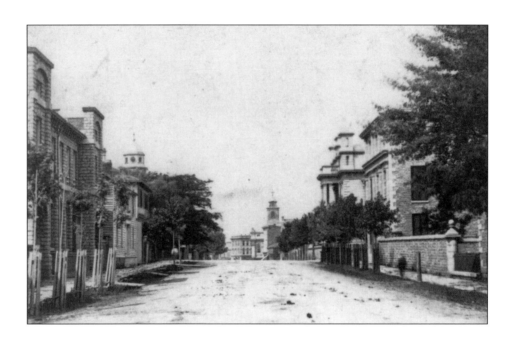

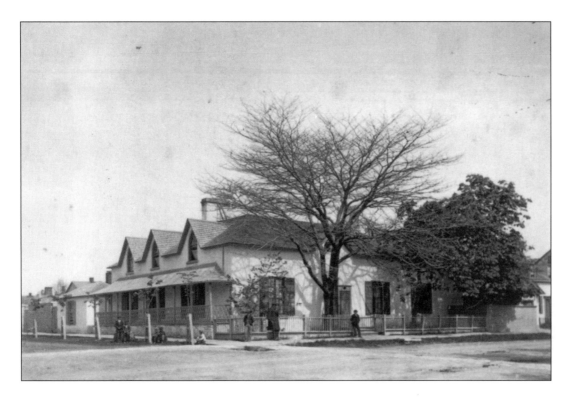

Residential District, c. 1860s.
National Archives of Canada #PA-119319.
Photographer: Sheldon and Davis.

The mouth of the Cataraqui River was originally chosen as the site of the new settlement of Cataraqui because of its fine harbour. French ships could pull into the estuary at the mouth of the river, protected from the fierce gales off Lake Ontario by the spit of land which curled around the bay.

This made Cataraqui a natural point at which the smaller bateaux and Durham boats needed to transport goods up the St. Lawrence could be offloaded onto larger sailing vessels for the voyage up the Great Lakes. The larger ships made good economic sense. The bigger the ship, the more furs that could be transported from the interior at the same time, decreasing transportation costs. Fort Frontenac was built to protect this new harbour from the competition: the British, and their Iroquois allies.

In 1758, Fort Frontenac was captured by British forces under the command of Colonel Bradstreet. This marked a decline in Cataraqui's fortunes, as the major fur trade route was diverted south to the British-controlled Hudson River, instead of continuing to follow the French-dominated St. Lawrence route.

Another blow came during the Revolutionary War when Captain Twiss recommended in 1778 that the British Navy build a fort on the newly renamed Carleton Island instead of building at Cataraqui. Throughout the conflict, the new fort, Haldimand, took over the roles Cataraqui had played, both as a military centre and as a major shipping port.

For the duration of the war, only naval ships of the provincial marine were permitted on the lakes. After the war, the expected influx of settlers and supplies to the area created the need for the re-establishment of a commercial shipping industry at the head of the St. Lawrence River. Since Carleton Island was too small to handle the expansion, the old site at Cataraqui was pressed into service (Preston, 1954).

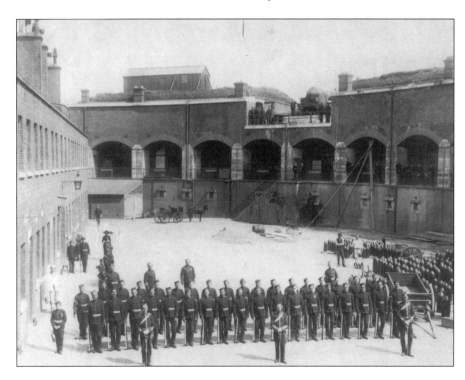

British Troops at Fort Henry, 1867.
National Archives of Canada #C-55511. E. Gary Carroll collection.

By the mid-1800s, the legislature of the United Province of Canada was deadlocked. Initially, Canada West and Canada East each sent forty-two representatives to the house and, under the double majority system then in use, legislation had to be approved by a majority of representatives from both jurisdictions (Bourrie, 1998). However, the anglophone population was divided along regional, religious, and political lines, while francophones enjoyed a solidarity born of a common language and culture. The anglophone vote was fractured among many parties, while francophones voted en masse with whatever party served them best. The result was that new governments were continually being formed, only to be defeated almost immediately, once after a tenure of only two days.

George Brown, responding to the inevitability of growth in Canada West outstripping that in Canada East, first proposed representation by population in 1853. Not surprisingly, francophones voted against the initiative, as an increase of representatives in Canada West would tip the balance of power against them.

By June 1864, the union had seen three separate governments come and go. The province was at a crossroads, and the solution which presented itself was confederation of the two Canadas with the rest of British North America. This move would, in one fell swoop, increase the anglophone population enough to overwhelm the francophone vote. Initial negotiations began in Charlottetown in September 1864, and, after three long years, Confederation was proclaimed Monday, July 1, 1867 (Waite, 1962).

Proclamation of Confederation, Market Square, July 1, 1867.
Queen's University Archives #PG-K 142-1.

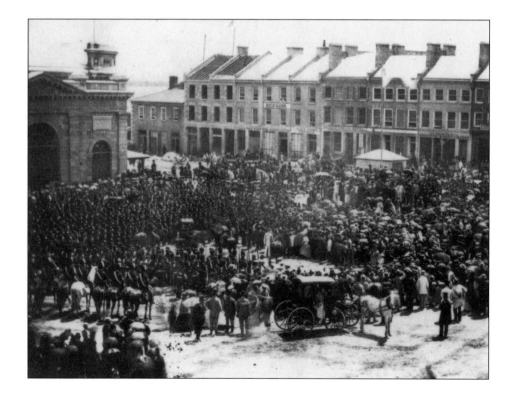

12

Brock Street, c. 1875.
National Archives of Canada #PA-103120.
Edward McCann collection.

Michael Grass was born in Strasbourg about 1732. Around his twentieth birthday, Grass left his homeland, possibly to avoid conscription by the French, who had controlled the area for almost three quarters of a century.

In September 1752, Grass found himself in Pennsylvania, where he worked as a saddler. Four years later he was captured by the French and imprisoned at Fort Frontenac until his escape several months later.

In August 1775, Grass was named a captain in the local militia, but he refused the commission. Two years later he was forced to seek asylum in New York, which was under the protection of the governor, Sir Guy Carleton. Numerous other Loyalists had also sought shelter there, and in order to ease the pressure of such an influx, Carleton decided to resettle the Loyalists along the banks of the St. Lawrence. Knowing Grass had spent some time at Cataraqui during his incarceration by the French, Carleton offered him a special commission to lead the Loyalists and establish a settlement in the area.

Captain Grass and his band of 983 settlers left New York in 1783 in about half a dozen ships, and arrived at Sorel, Quebec, in the early fall of the same year. The main party was quartered there, while an advance party continued up the St. Lawrence in bateaux to Cataraqui. After some initial surveying, Grass and the majority of his advance party retired to Sorel for the winter. Seventeen of the settlers elected to winter at Cataraqui.

The following May, the entire party set out for their new home (Grass, 1964). The governor had been most generous with the colonists, allowing them provisions for three years, including some shoes and other clothing, foodstuffs such as flour, cured meat, butter, and salt, as well as a quantity of seed for planting crops. The governor also ensured the colonists had sufficient farming implements such as axes, hoes, spades, and ploughs (Machar, 1907).

King Street looking south from the Market, 1885.
Queen's University Archives #PG-K 126-2.
Photographer: J.W. Powell.

14

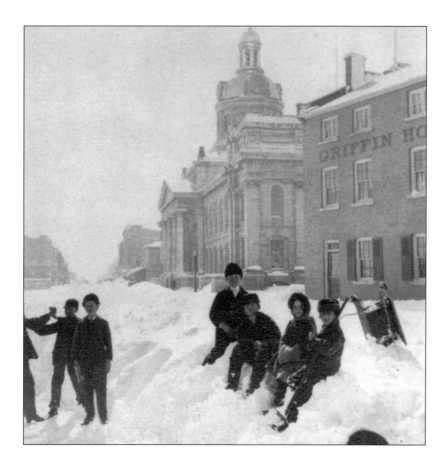

City Hall, 1875.
National Archives of Canada #PA-103095.
Photographer: Henry Henderson.

Barrie Street after the ice storm, c. 1890.
Queen's University Archives #PG-K 124-4.
Photographer: Henry Henderson.

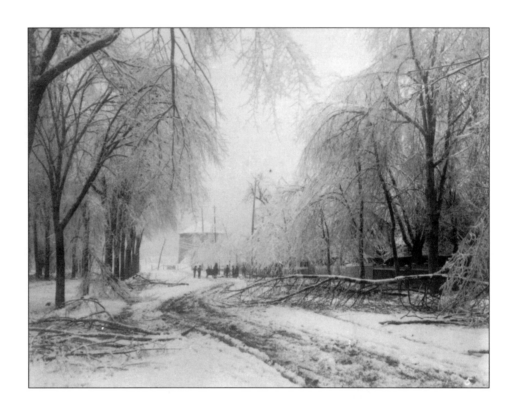

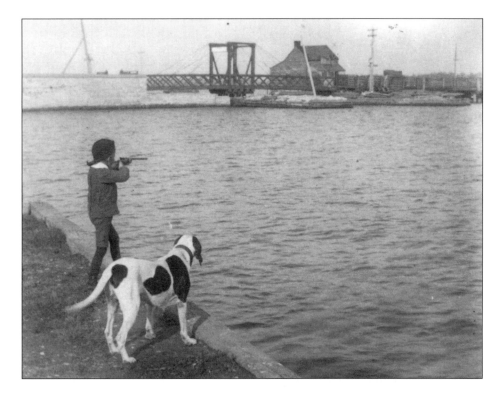

A boy and his dog, c. 1886.
National Archives of Canada #PA-164326.
Photographer: Frederic Hathaway Peters.

The first few women to practise medicine in Canada served as an inspiration to many other women. Dr. Jennie Trout, practising in Toronto, inspired Elizabeth Smith, of Winona, Ontario, to follow in her footsteps. Smith, the only daughter of well-off parents, was encouraged at every turn by her family. It was on her behalf that the rector of the Hamilton Institute petitioned the Royal College of Physicians and Surgeons of Kingston in 1877 to admit women to medical school.

This led the college to institute a summer course for women wishing to study medicine in Kingston. Although several women contacted Smith regarding the opportunity to study medicine, only four, including Smith, could raise the funds needed to enter the first session in April 1880.

This first freshman class endeared themselves, not only to their professors, some of whom stayed on through their scheduled holidays to give lectures, but also to the townspeople, who were fascinated by them.

The following year the segregated summer course was scrapped in favour of co-ed classes, and, in October 1881, the women began attending regular classes with their male counterparts at the college. The male medical students were courteous and supportive throughout that first year. However, with the graduation of the senior class, all that changed.

The majority of the remaining students, aided and abetted by a few of the junior staff, harassed the women unmercifully throughout the semester. By the beginning of December 1882, things came to a head. The female students walked out in the middle of a Physiology lecture. During the next ten days, the male students refused to attend lectures, and resolutions flew back and forth between them and the faculty. Finally, a deal was struck which allowed the female students to finish out the year. After the segregated classes resumed, it was decided to establish a separate medical school for women.

This solution was enthusiastically adopted by students, faculty, and townsfolk alike, and in June 1883, work frantically began to find faculty, funds, and facilities in time for the proposed entering class to begin in October. The city of Kingston promptly donated several rooms in City Hall, including Ontario Hall, for the new facility. All was ready on the appointed day for the eleven students of the new college.

Although supported wholeheartedly, the college could not compete with rival schools in Toronto and Montreal. Faced with declining enrollment after a decade of valiant effort, the college was dissolved in September 1899 (Travill, 1982).

First telephone cable being laid, 1881.
Queen's University Archives #PG-K 163-16. Rob Buttle collection.

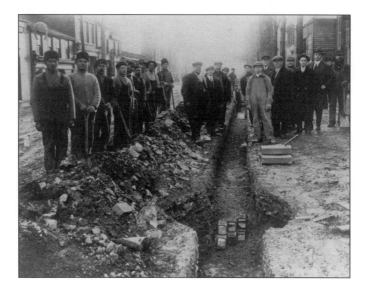

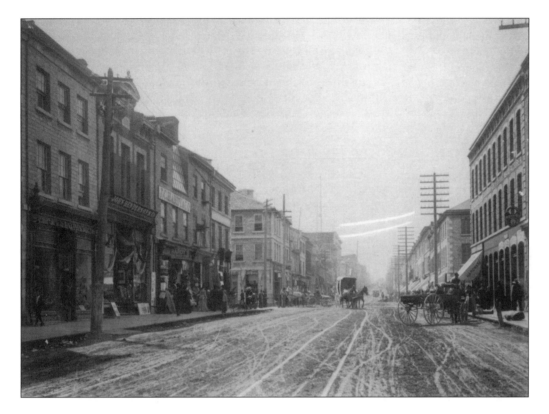

Princess Street looking west from Wellington, c. 1890s.
Queen's University Archives #PG-K 128-1.
Photographer: Henry Henderson.

The citizens of Kingston have always had access to a fine variety of entertainment in their city. The fact that it was a garrison town, drawing a steady stream of soldiers from all over the British Empire, meant the community had no lack of talent within its confines. However, the consensus by the mid-1870s was that the best in live entertainment was bypassing Kingston in favour of other communities in the region. The blame for this was put squarely on the fact that existing facilities, namely those at City Hall and the Victoria Music Hall, were too small to accommodate the better acts which were touring North America at the time.

In March 1878, after several years of false starts and abandoned plans by various groups in the city, W.C. Martin proposed the building of an Opera House. Construction began in September, and was completed in time for the grand opening on January 6, 1879. Unfortunately, the premiere was marred by poor scene changes, no artificial lighting, and insufficient heat. Despite this inauspicious start, the Opera House continued to draw crowds with the top-notch performances it attracted, until a fire, sparked by unknown causes, razed the building in December 1898 (Waldhauer, 1979).

Princess Street looking east from the Opera House portico, c. 1890s.
Queen's University Archives #PG-K 128-22.

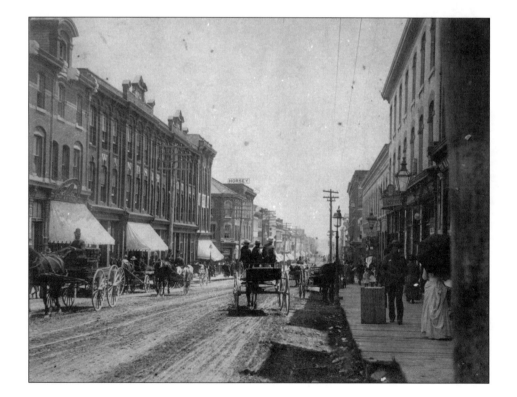

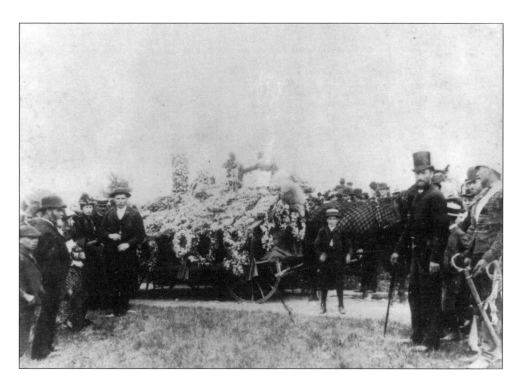

Sir John A. Macdonald's coffin, 1891.
Queen's University Archives #PG-K 152-10A.

City Hall draped for the death of Queen Victoria, January 1901.
Queen's University Archives #PG-K 151-2.

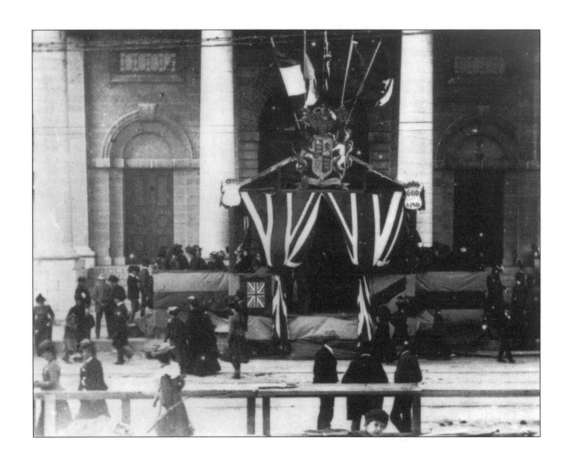

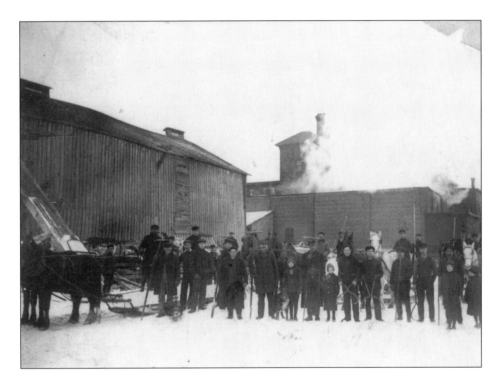

Ice factory.
Queen's University Archives #PG-K 163-1A.

John Alexander Macdonald was born January 11, 1815, in Glasgow, Scotland. He immigrated to Kingston five years later, where he passed the bar at age 21. He practised law in Kingston for many years, and was involved in a wide range of duties in town, both legal and otherwise, throughout his life.

Macdonald was first elected as the Conservative member for Kingston in 1844, four years after Union was declared. Thirteen years later he formed a coalition government with Sir George-Étienne Cartier. When George Brown, leader of the Opposition, threw his support behind the government's proposal for Confederation in 1864, Macdonald invited the leaders of the other North American provinces independent of the United States to join him at Charlottetown for negotiations. Once the British North America Act was passed in 1867, the Dominion of Canada became a reality, and Macdonald became Canada's first prime minister.

Macdonald was knighted for his efforts and, under his leadership over the next four years, the four original provinces were joined by Manitoba, British Columbia, and Prince Edward Island. Although Macdonald's administration was rocked by scandal soon after, forcing him to resign, he returned to power in 1878, and continued as prime minister until his death in Ottawa on June 6, 1891 (*The New Encyclopaedia Britannica*).

Cutting ice on the bay, 1894.
Queen's University Archives #PG-K 163-4. Mrs. de L'Panet collection.

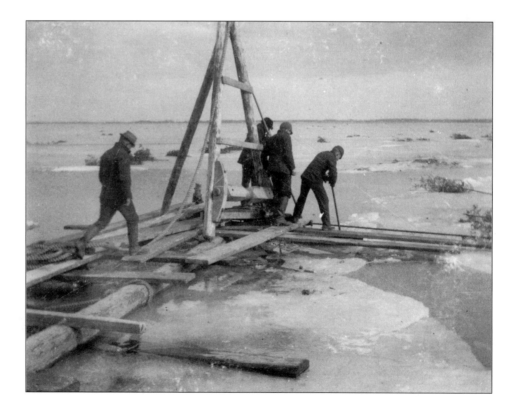

John Palmer Litchfield was a reporter whose time masquerading as a doctor landed him in an Australian debtors' prison in the early 1800s. Upon leaving prison, Litchfield set sail for Canada, where he met John A. Macdonald. In 1854, Litchfield leased Rockwood Villa, built by George Browne for John Solomon Cartwright on his estate outside Kingston. By using Macdonald's name, and the skills he had learned to pose as a doctor in Australia, Litchfield was also able to obtain a licence to operate an asylum for Kingston's elite.

Litchfield then campaigned long and loud for the government to establish a public asylum at Kingston, thus treating the elite separately from the criminals with whom they were currently housed in the penitentiary. In the fall of 1856, the government acquiesced. However, the actual construction was delayed by three more years. In the interim, the Villa's stables were refurbished to shelter twenty-four female inmates who transferred from the penitentiary. The stables continued to house female inmates until 1868.

Although the new asylum was built, using local limestone, by convict labour, supposedly providing a considerable savings over contracting out the work, the government complained continually about the cost of guards to oversee the labour. Work slowed to a crawl as Litchfield fought for enough money to complete the facility. Finally, after observing that operating costs could be curtailed if the insane at Kingston Penitentiary could also be housed in the new asylum, Litchfield got his wish. The building was completed in the spring of 1859 (*125 years keeping people healthy*, 1981).

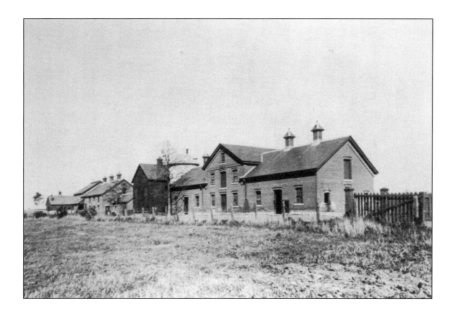

Stables at Kingston Asylum, c. 1900.
Queen's University Archives #PG-K 104-32.

25

Beechgrove, Kingston Asylum, c. 1900.
Archives of Ontario #RG 15-82-01 #19.

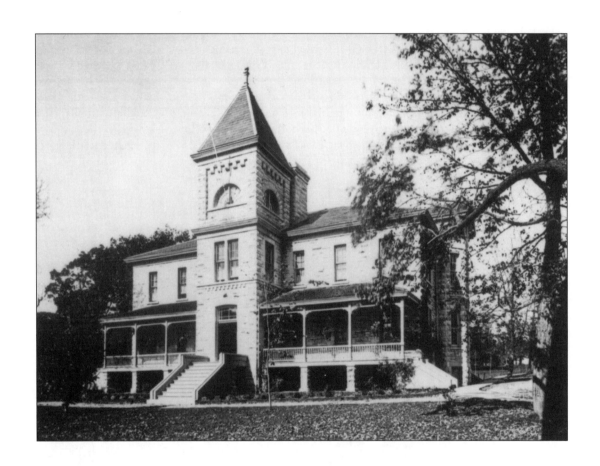

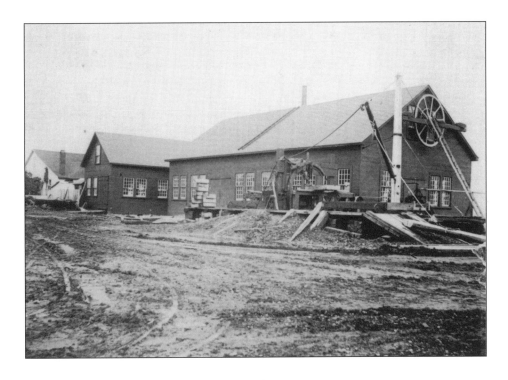

The sawmill on Garden Island.
Queen's University Archives #PG-K 174-11.

Dileno Dexter Calvin was born on May 15, 1798 in Vermont. When he reached the age of 20, Calvin left Vermont, and soon began pioneering in upstate New York. In the beginning, Calvin concentrated on farming. Then, in 1825, he first tried his hand at transporting lumber down the St. Lawrence.

After a decade of trying to juggle both farming and lumbering, Calvin took up lumbering full-time. In 1835, he and his family moved to Clayton, New York, on the banks of the St. Lawrence. The following year, along with his two partners, Calvin rented space for his lumber operation on Garden Island. Calvin continued to live in New York for many years, until finally moving to the island in 1844.

Calvin's company expanded greatly throughout most of the nineteenth century because of his shrewd business sense. Although the company did log its own timber, they mostly transported lumber for others. This protected them somewhat from fluctuations in market prices, bringing in a steady fee for each delivery. Another point in Calvin's favour was his willingness to diversify. In addition to rafting lumber down river, his company also warehoused merchandise, manufactured goods, built ships, and owned their own fleet.

By 1862, the company had bought the whole of Garden Island, and in 1880, Calvin was able to buy out his partners' shares in the land. Calvin controlled the company until his death in 1884. His son, Hiram Augustus, took over and ran the business until 1914, when operations were suspended due to the war (Swainson, 1980).

The sawmill and engine house, Garden Island.
Queen's University Archives #PG-K 174-9.

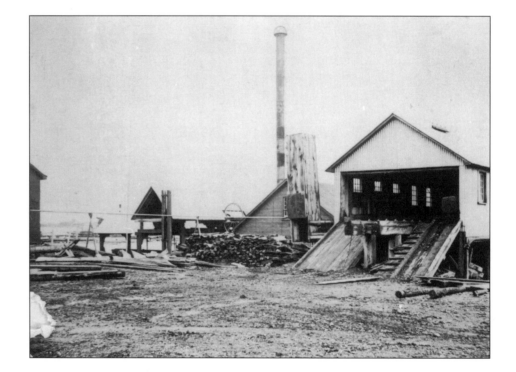

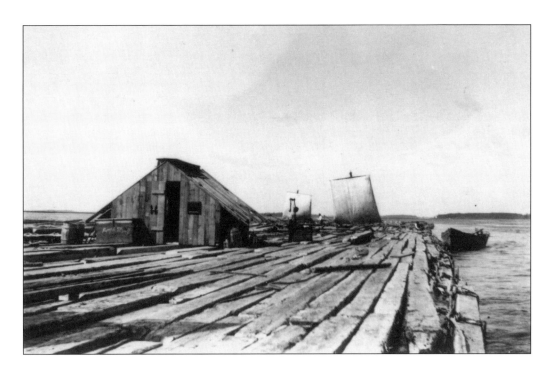

Timber raft, 1898.
Queen's University Archives #A.ARCH V,23 Boa-Tim-1.

Assembling cribs into a raft.
Queen's University Archives #A.ARCH V.23 Boa-Tim-5.

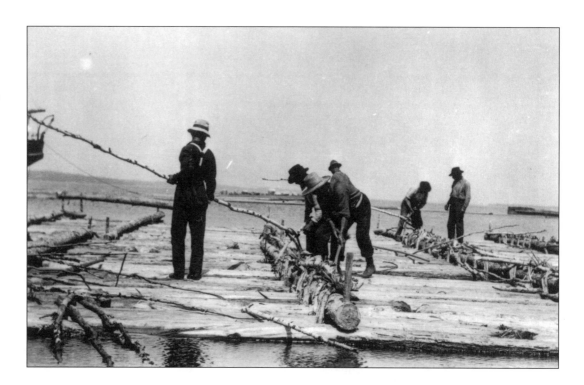

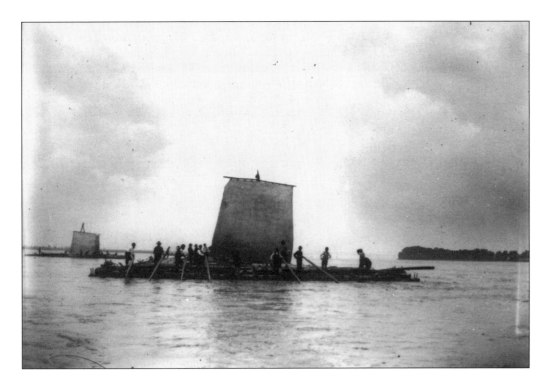

Going downstream.
*Queen's University Archives #A.ARCH V.23 Boa-
Tim-4.*

Rafting timber down the St. Lawrence to Quebec City was both exciting and dangerous. However, assembling the rafts could be tedious, and was undeniably hard work. First, workers constructed several cribs, sixty- by forty-two-foot frameworks, which were filled with sticks of timber. The majority of the lumber was oak and pine, and these had to be mixed together as the pine provided sufficient buoyancy to float the oak, which sank on its own.

Once four or five cribs were assembled, they were fastened together into a dram up to three hundred feet long. When a dozen or more drams were ready, they were bound together into a huge raft. Some could be a half mile or more in length when completed. Once the raft was completed, the workers erected sheds for cooking and sleeping directly on the sticks which made up the home dram. When the crew had stowed enough supplies to last the trip, which could take more than a month, they hoisted sail and headed for the first of many sets of rapids on the way to Quebec.

The rafts travelled round the clock until they came upon a set of rapids. Shooting the rapids was dangerous work, which the crew only attempted during the day. First, the rafts were disassembled into drams, each of which was piloted through the rapids separately. Occasionally, a dram would fall apart en route, and much time would by lost as the crew reassembled as many of the sticks, each branded with the company's insignia, as possible (Swainson, 1980).

The chef at work, 1905.
Queen's University Archives #A.ARCH V.23 Boa-Tim-2.

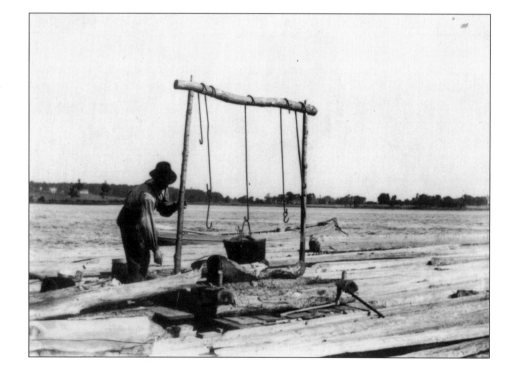

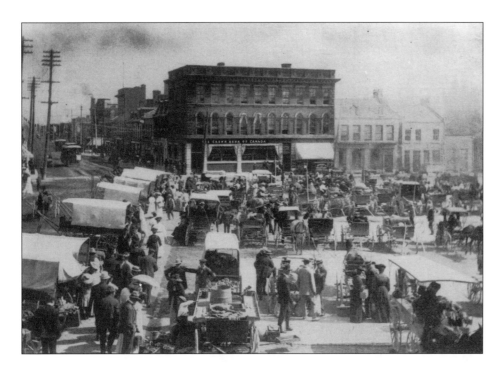

Market Square, 1907.
Queen's University Archives # PG-K 121-5.

Fire at City Hall, 1908.
Queen's University Archives #PG-K 110-15A.
Irene Mooney collection.

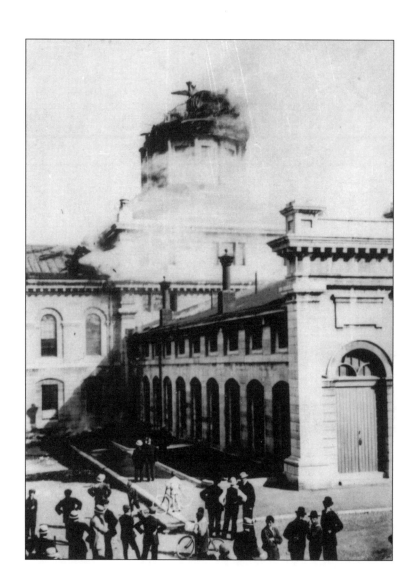

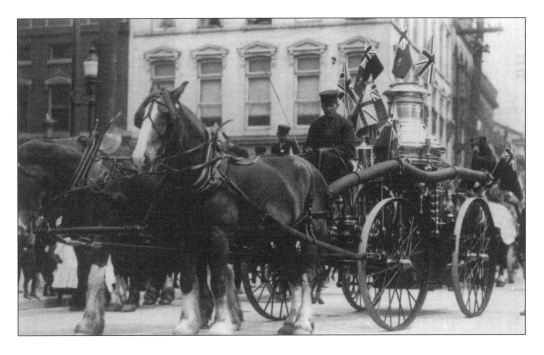

Firefighters on parade.
Queen's University Archives #PG-K 148-24.

A hard gale was blowing the night of April 17, 1840. The ships docked at Kingston harbour that Good Friday evening were being tossed about, sorely straining their mooring ropes.

About midnight, the captain of the steamer *Telegraph* decided his ship had taken enough of a pounding against the wharf. He ordered his crew to fire up the boilers so he could weather the rest of the blow in deeper water.

Around half past twelve, Richard Palmer, on night duty at his bakery, scanned the buildings on the waterfront. Upon looking closely at the flickering light inside the warehouse leased to the Ottawa and Rideau Forwarding Company, Palmer realized the building was on fire. He roused his brother, then ran to the engine house on Brock Street. When Palmer found the building locked, he returned to the bakery.

A cook on the steamer *Cataraqui* also noticed the flames and, rousing the rest of the crew, joined their attempts to free the ship from her berth beside the blaze. The ship had been moored fast the previous evening because of the high winds, delaying the crew's efforts. Once freed, the pounding waves prevented the ship from leaving, and she caught fire in a matter of minutes. When the crew abandoned ship, the wind shifted, and she floated into the harbour. Both the *Cataraqui* and the *Lord Nelson*, which was also alight, drifted towards the Penny Bridge over the mouth of the Cataraqui River.

The smaller of the two ships, the *Lord Nelson*, was also lighter, and quickly covered the distance to the bridge, setting it ablaze. Fortunately, by this time the alarm had been raised. Colonel Henry Dundas, commander of the garrison, had seen the threat the wayward ships posed and posted his men, as well as those of Captain Sandom, on the bridge. While Dundas's troops quelled the fire on the bridge, Sandom's men, in several longboats, managed to secure the *Lord Nelson* and tow her to deeper water, where the fire was eventually extinguished.

The *Cataraqui*, also bound for the bridge, was intercepted by Sandom's men before she reached her target. She too was towed farther into the harbour and her flames were subdued.

Meanwhile, the fire in town had been confined mainly to Front Street, save a few roof fires, by the hard work of the townspeople. The citizens, including the children, turned out en masse to fight the blaze. Aided by the military, who provided much in the way of materials as well as manpower, it seemed in the first few hours that the damage could be confined to the waterfront despite the heavy winds.

Shortly after two a.m. nearly one hundred kegs of gunpowder, improperly stored in a warehouse on the wharf, ignited. The explosion rocked the town and propelled burning timbers hundreds of feet from the waterfront. Half the windows in town were broken, and doors along Brock Street were blown open by the force of the blast. The explosion literally knocked the exhausted firefighters off their feet. Paralysed by the shock of the blast, as well as the magnitude of the disaster, the townspeople were slow to react. The flames were fanned by the gale, and the fire gained new vigour, racing westward, and consuming all the buildings along the market.

The fire was finally subdued near dawn just before it engulfed the Commercial Bank building. The west side of King Street had been spared by a change in the wind's direction. Houses along the lower reaches of Clarence Street had been saved by quick-thinking souls who pulled down a burning tavern.

Along the waterfront, from Johnson Street to Brock, there were only ashes. In the area bounded by Market to Store Street and Front to King, only four buildings survived. In addition to the myriad businesses lost in the fire, some forty houses were razed, leaving forty-five families homeless. Although there were numerous injuries, some of them serious, no one was killed.

A month after the fire, several measures were adopted in an attempt to prevent a recurrence. The most important of these was a recommendation that wooden buildings be prohibited in the centre of town. Thus, the city that was rebuilt was, by and large, built of stone ... limestone (Spurr, 1970).

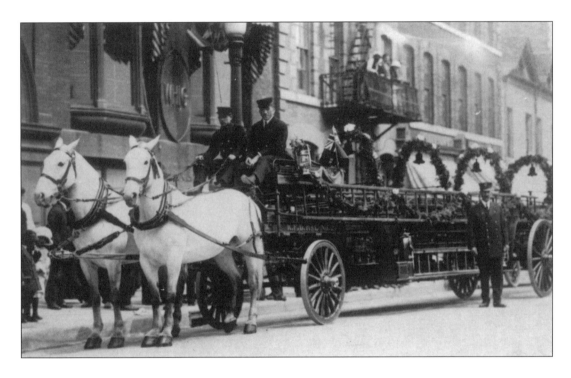

The white team, c. 1915.
Queen's University Archives # PG-K 148-21.

Canadian Locomotive Company Ltd., c. 1916.
National Archives of Canada #PA-56127.
Photographer: C.M. Johnston.

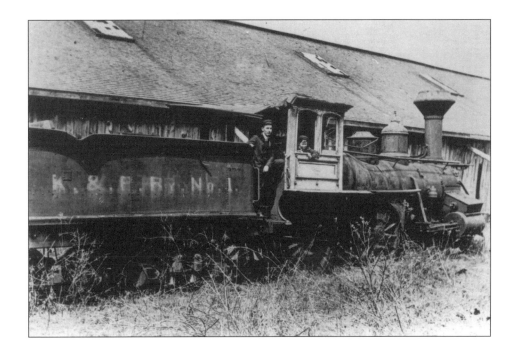

The first Kingston and Pembroke locomotive at the carworks on Montreal Street.
Queen's University Archives #PG-K 182-10A.

Kingston and Pembroke railway station.
Queen's University Archives #PG-K 97-1.

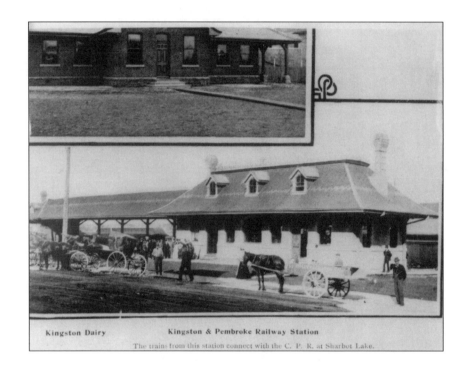

Kingston Dairy Kingston & Pembroke Railway Station

The trains from this station connect with the C. P. R. at Sharbot Lake.

The Outer Station, Montreal Street.
Queen's University Archives #PG-K 97-7.

Big Pit, Eagle Lake Phosphate Mine.
National Archives of Canada #PA-50996.
Photographer: Horatio Nelson Topley.

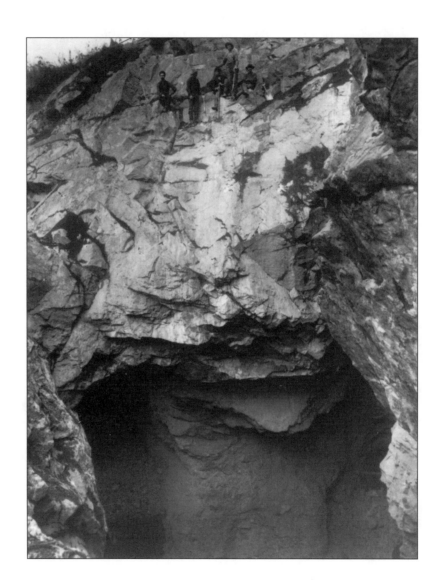

During the 1870s, when the town began to face hard economic times, the idea of tapping the resources of Kingston's back country first surfaced. As in numerous other commercial centres in North America, many schemes for linking the major centres via rail were proposed (Preston, 1954).

One of the more successful of these endeavours was the Kingston and Pembroke Railway, or K and P. Known locally as the Kick and Push, the company, launched in the spring of 1871, was headed by C. F. Gildersleeve. Gildersleeve, an energetic and dynamic man, travelled extensively throughout the region speaking on behalf of the railway.

The original plan was to run the line, as the name implied, from Kingston to Pembroke. However, the reality of laboriously cutting through the Canadian Shield proved daunting. While the ground was ceremoniously broken in the spring of 1872, it took four years and two different contractors for the rails to be laid as far as the Mississippi River.

This, although slightly more than half of the 112 miles to Renfrew, proved to be the easy part of the task. Bringing the tracks the rest of the way entailed laborious blasting and hauling of tons of rock, as well as construction of a causeway over Calabogie Lake. After obtaining yet another contractor to take on the job, the line to Renfrew was completed in 1884. Financial difficulties, however, prevented the K and P's expansion to Pembroke.

After a quarter century of service, in constant competition with other small railroads in the region, the old management was gradually phased out. The company was bought outright by Canadian Pacific in the early 1900s (Bennett and McCuaig, 1981).

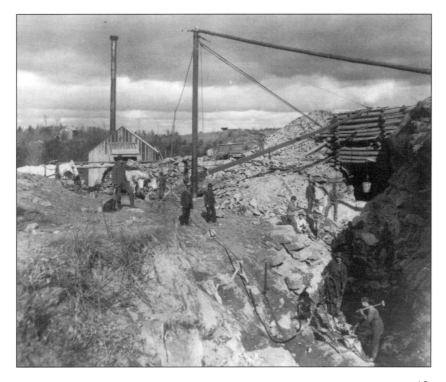

Entrance, Eagle Lake Phosphate Mine.
National Archives of Canada #PA-50972.
Photographer: Horatio Nelson Topley.

**Camping near Washburn Mills Locks,
September 1913.**
National Archives of Canada #PA-16801.
Photographer: H.J. Woodside.

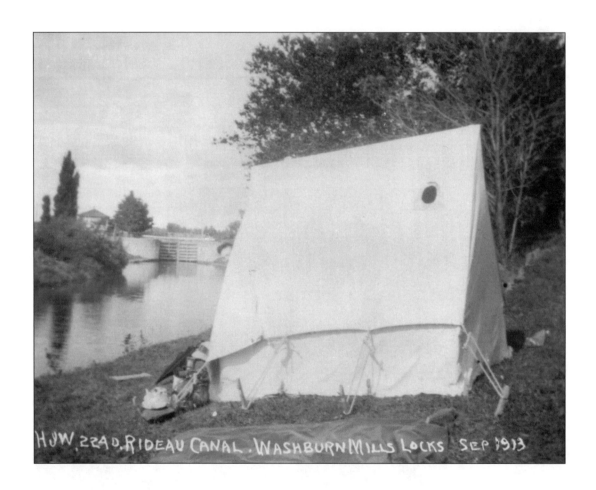

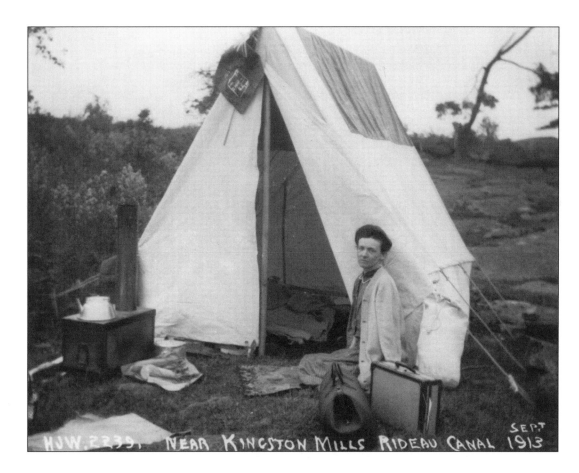

Camping near Kingston Mills, September 1913.
National Archives of Canada #PA-16802.
Photographer: H.J. Woodside.

Lower Lock, Rideau Canal, c. 1880.
National Archives of Canada #PA-8883.
Photographer: William James Topley.

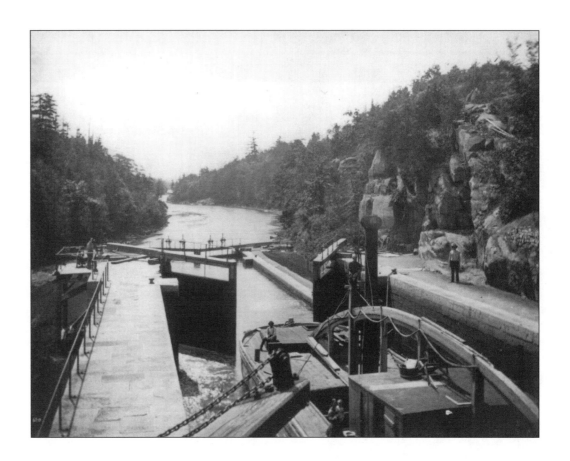

The *Mitzi* exiting Kingston Mills Lock, 1914.
National Archives of Canada #PA-143622. Photographer: Russell K. Odell.

Due to the difficulty of shipping goods up the St. Lawrence during the War of 1812, Parliament decided in 1822 to strike a committee to study the feasibility of building a canal from the Ottawa River to the Great Lakes. The committee retained an engineer, Samuel Clowes, to estimate the cost of such an undertaking. In 1825, Clowes recommended the building of a canal five feet deep, with locks eighty feet long and fifteen feet wide.

The British government, mindful of the strategic importance of such a canal, immediately took over the venture, and in 1826 dispatched Lieutenant-Colonel John By to oversee the enormous project.

The initial plans approved by the government stipulated that the canal have a depth of four feet, and that the locks be eighty feet long and twenty feet wide. Upon reviewing the proposed route, By made several alterations to the scheme, suggesting that the total depth be increased by a foot, and that the locks be made 150 feet long and fifty feet wide to accommodate larger steam

vessels. He also made several other changes, including the relocation of both ends of the canal. For the north entrance, By chose Sleigh Bay as the site of the initial series of locks, and on the southern entrance, By opted for Kingston Mills instead of Clowes' preferred site three miles west of Kingston. Although Sleigh Bay turned out to be an excellent choice, the shallow, muddy bottom below Kingston Mills has proven problematic, supporting the contention that perhaps Clowes' site would have been better.

Work on the canal commenced on September 19, 1827, however, the British government, not at all sure that these extra measures were warranted, sent a special committee to Canada in early 1828 to study the canal's progress. The committee came back with recommendations supporting By's own.

In the spring of 1832, a mere five-and-a-half years after it was begun, the Rideau Canal was finished – one of the greatest feats of colonial engineering in the New World (Patterson, 1971).

Old mill and falls, Kingston Mills, 1913.
National Archives of Canada #PA-61026. John Boyd collection.

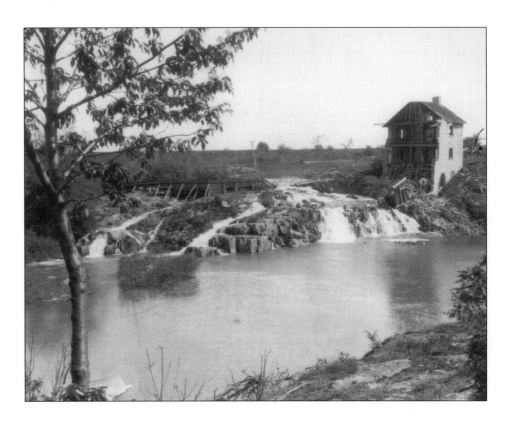

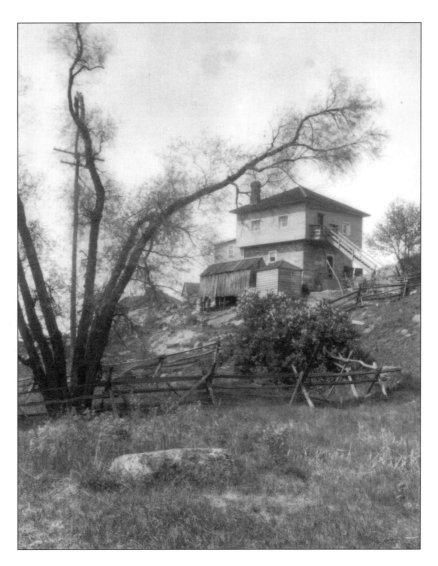

Blockhouse, Kingston Mills, 1913.
National Archives of Canada #PA-61027. John Boyd collection.

Delivering bread, 1915.
National Archives of Canada #PA-61467.

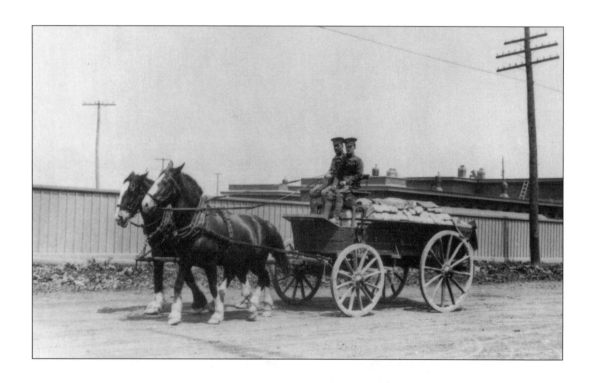

hen the British took over Upper Quebec, including what was then the settlement at Cataraqui, in 1758, they adapted the seigniorial system which had been in use under the French regime. The rights and obligations formerly attributed to the Seignior were transferred to the Crown.

In 1783, the need to re-settle Loyalists along the banks of the St. Lawrence necessitated the expansion of the Crown's seigniorial obligations. In particular, the settlers would require the use of both a saw mill for cutting lumber and a grist mill for grinding flour. In exchange for the expense of construction, the Crown received a monopoly on both enterprises throughout the area.

Although Cataraqui Falls was a good five miles upstream from the settlement, the height of the falls and the volume of water passing over them made them irresistible as the site of the needed mills. Construction began in the fall of 1783, but was soon halted by inclement weather. The building continued as soon as spring arrived and was finished in short order.

Of excellent capacity for such a small settlement, Kingston Mills proved unpopular with the locals. The lack of roads made transporting grain and timber overland to the site difficult. In addition, the constant wind blowing inland from the lake made floating the sawn lumber back to the settlement by water time consuming.

In 1791, the Constitutional Act was passed, ending the Crown's milling monopolies. Since the government would now be in competition with private ventures, they decided to lease the mills for a set annual fee. For the next forty years, several tenants tried to turn a profit at Kingston Mills, but were mostly unsuccessful. Finally, in 1840, the lease was transferred back to the military (MacKay, 1977).

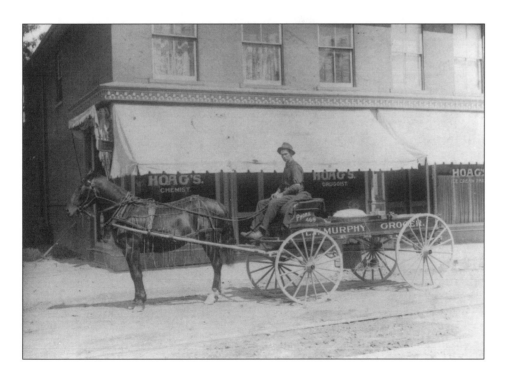

The grocer's wagon.
Queen's University Archives #PG-K 185-9.

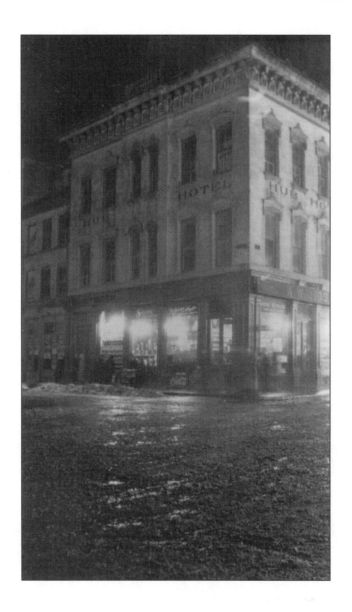

King Street at night, 1916.
National Archives of Canada #PA-56126.
Photographer: C.M. Johnston.

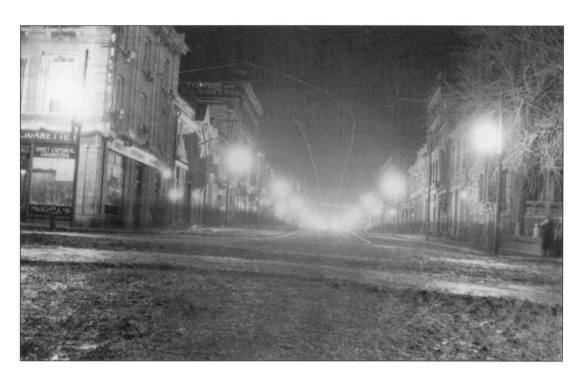

Streetlights on Princess Street, 1915.
National Archives of Canada #PA-56163.
Photographer: C.M. Johnston.

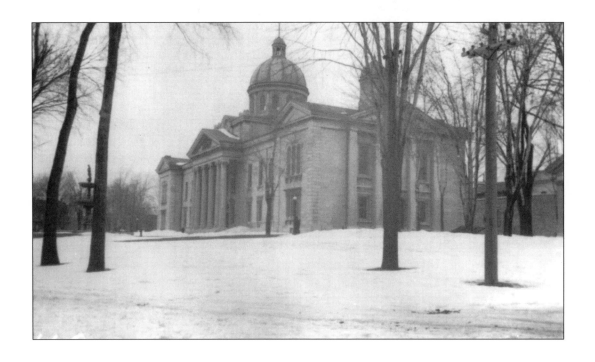

County Court House, 1916.
National Archives of Canada #PA-56149.
Photographer: C.M. Johnston.

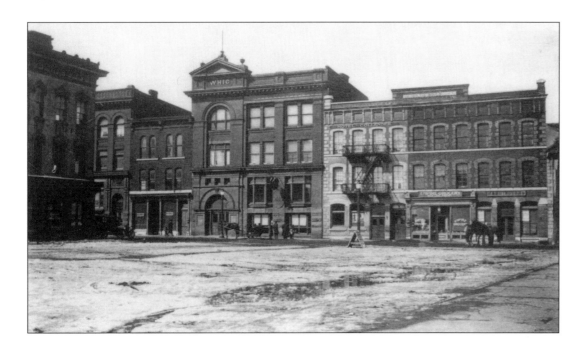

King Street, 1916.
Queen's University Archives #PG-K 121-3.

Lowering the flag, Barriefield School of Signalling.
National Archives of Canada #PA-110416.
Photographer: W. Harold Reid.

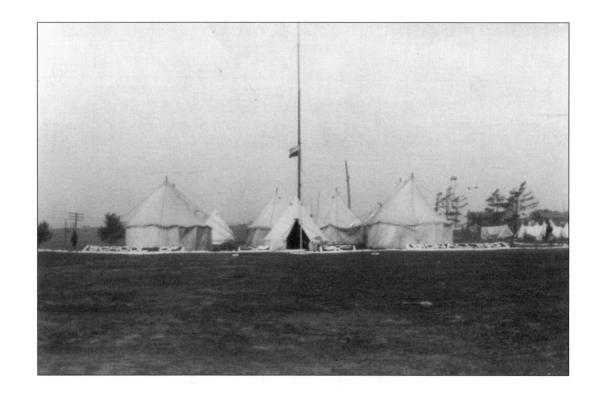

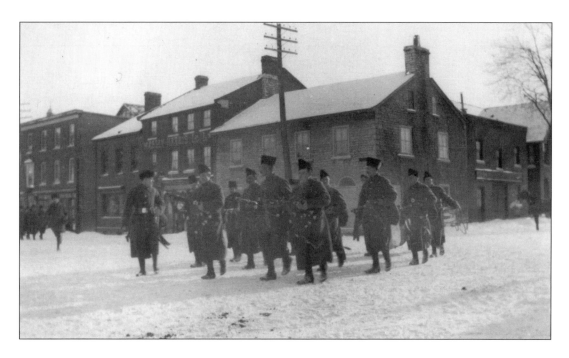

Military pipe band, 1916.
National Archives of Canada #PA-56116.
Photographer: C.M. Johnston.

Soldiers grooming horses, Barriefield camp, 1915.
National Archives of Canada #PA-61464. John Boyd collection.

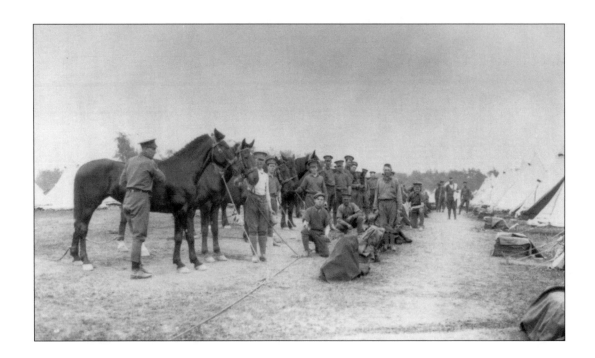

Many people dissatisfied by British rule in Canada went to the United States in the early nineteenth century. Some Canadians who went, like the leader of the Reformers, William Lyon Mackenzie, spoke out against the supposed tyranny in their native land and tried to stir up anti-British sentiment in the States. These attempts were quite successful, partly because of the lingering bad feelings left over from the Revolutionary War and the War of 1812.

By the middle of 1838 this anti-British attitude had led to the establishment of over one thousand Hunter's Lodges, whose members were sworn to oust the British from North America. Members, garnered from among disenfranchised Canadian expatriates and their American comrades, were attracted both by the noble ideology as well as by the cash incentives. These zealots believed that the majority of Canadians felt as Mackenzie did and would welcome an American attempt to liberate them from the British, much as the American Revolution had freed the United States. In addition, the Hunters were told by John Ward Birge, one of the highest officers in the organization, that even soldiers in the Canadian army would join their cause.

Northern New York State boasted a lodge in practically every major town, including one in Syracuse. It was the members of this lodge that Nils Szoltevky von Schoultz led under Birge in an attack on Prescott in November 1838. Von Schoultz, a major in the Polish army, had come to the States two years earlier. He fervently believed, as did all the invaders, that the Canadians would welcome them with open arms.

On November 11, 1838, Birge set off for Canada with a steamer and two schooners full of men and arms. However, as he neared the shore, Birge lost his nerve and, under the pretext of rallying the good citizens of Ogdensburg to join their cause, deserted. Von Schoultz assumed command of the little fleet, and planned to land his troops at Prescott and attack Fort Wellington by surprise.

Unfortunately, the pilots in charge of the sailing vessels that Sunday night missed the dock at Prescott and ran aground. The Hunters were able to free one of their ships, which floated downstream to Windmill Point. The other ship remained stuck fast until Monday afternoon, when she joined her sister ship at the point.

Von Schoultz now found himself in a tenuous position. The surprise attack, which he had hoped would carry the day, was out of the question, as they had already been in Canadian waters for twenty-four hours. Fortunately, they had landed at an incredibly defensible position. The windmill and surrounding buildings were built of stone and offered excellent protection from the attacking British. This, coupled with the fact that the Hunters believed Canadians would join them, enticed them to hold their ground.

British forces began the attack on the Hunters on Tuesday morning. British fire made little impact on the invaders' position, as the windmill's three-and-a-half-foot-thick walls protected those inside from the worst of the barrage. In addition, the Hunters had mounted their three cannons outside the windmill's door and the volleys from these guns kept naval vessels far enough away to prevent any direct hits from that quarter.

On Wednesday a truce was called to enable both sides to dispose of their dead. During this time, a steamer named the *Paul Pry* crossed to the Point, and those aboard advised the Hunters to leave. The Hunters refused, believing that reinforcements were en route from Ogdensburg.

The refusal was a fatal mistake. Additional troops and heavy artillery had been sent, but to aid the British, not the invaders. On Friday,

November 16, the fortified British forces made an all-out attack on the Point. A barrage of cannon fire rained down on the windmill, both from the landward side and from two gunboats and a steamer on the river. Although the assault failed to demolish the windmill, it was sufficient to force the Hunters to surrender.

The 130 captives were bound and marched to Prescott, where they boarded a steamboat bound for Kingston. Late that night they disembarked at Front Street and were paraded to Fort Henry through the brightly lit streets under the watchful eyes of thousands of jubilant citizens. Leading his men was the tall figure of von Schoultz, his clothing torn to shreds.

Von Schoultz was court martialled at Fort Henry in late November. Against the advice of his counsel, John A. Macdonald, von Schoultz pleaded guilty to the charges against him. When questioned, he stated that although false propaganda had influenced him to join the Hunters, he had in fact led the attack and was therefore guilty. Because of the serious nature of his crimes, the severity of the mandated penalty, and the improbability of the court lessening the sentence, his trial proceeded despite his plea. Von Schoultz was found guilty on Friday, November 29, and was sentenced to death by hanging. Just over a week later, on a Saturday, he was hanged at Fort Henry. His remains are still buried in Kingston (Stanley, 1954).

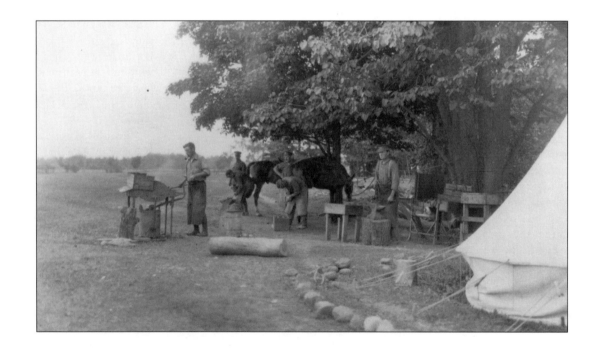

Outdoor blacksmith shop, Barriefield camp, 1915.
National Archives of Canada #PA-61364. John Boyd collection.

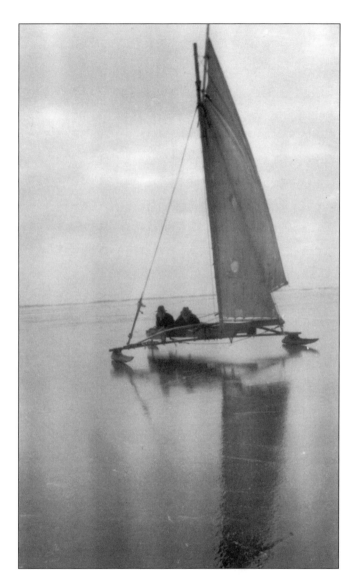

Ice boating in the harbour, c. 1916.
National Archives of Canada #PA-56151.
Photographer: C.M. Johnston.

A day on the ice.
Queen's University Archives #PG-K 197B-13.
Corfield Family Album.

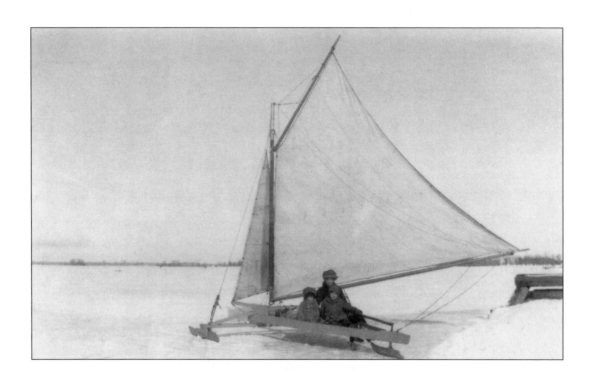

Winter crossing to Wolfe Island.
Queen's University Archives #PG-K 197B-12.
Corfield Family Album.

Today, the outbreak of a contagious disease can fly around the world in a day or two. During the age of sail, the time lag was much greater, but the progress of incurable diseases just as inexorable. And so, the outbreak of cholera which decimated India in 1817 followed the British to the Middle East. From there, it made its way to Russia and Poland, and finally to the rest of Europe. By October 1831, the outbreak had reached Great Britain. Six months later, the disease had run its course, except in Ireland, where the epidemic still raged.

When the ice cleared the St. Lawrence in the spring of 1832, the inhabitants of Upper Canada appeared nonchalant about the possibility of cholera reaching the New World. Even the medical establishment believed the vast Atlantic Ocean would form an insurmountable barrier to the transmission of the epidemic.

The citizens, however, were mistaken. The disease is characterized by diarrhoea, nausea, and vomiting, leads to decreased blood volume, a blue pallor, convulsions, and often death, and is transmitted when healthy individuals consume water tainted with infected faecal matter. Thus, the medical opinion of the day – that quarantine measures would not impede the progress of the disease – was to some extent correct.

To their credit, the government did take steps to prevent an outbreak in the Canadas. Local boards of health were quickly set up and empowered to take any steps necessary to preserve the public health. A quarantine station was set up at Grosse Île, east of Quebec City. All ships were inspected, and those with active cases of cholera were required to discharge their sick on the island.

On June 3, 1832, the *Carricks* was inspected at Grosse Île. Even though forty-two of her passengers had succumbed to the disease during the crossing from Dublin, all the survivors were cleared for passage to points upriver. Since none of those carrying the disease were detained, cases of cholera marked their progress, first striking Quebec City on June 6, then Montreal three days later. A week after the first cases had been detected in Quebec City, the first outbreak in Upper Canada was reported in Prescott. By the end of June, the citizens of Kingston had been infected with the disease as well.

Throughout the spring, the citizens rallied to lessen the severity of a possible outbreak. Measures recommended by the new board of health as well as civilian committees included the maintenance of a hospital specifically for cholera cases, a general cleaning up of the town and removal of rubbish, and the establishment of a quarantine on ships, which were expected to anchor one hundred yards out in Kingston harbour.

These measures were, on the whole, fairly successful. Although by summer's end 255 cases of cholera had been reported, and ninety-seven individuals had succumbed to the disease, the town numbered over four thousand, making the death toll a mere fraction of the population. Tragic though it was, this was nowhere near the number of lives lost in Quebec City or Montreal, where the victims comprised nearly one-seventh of the population (Spurr, 1975).

Sandy Bay lighthouse, Portsmouth.
Queen's University Archives #PG-K 197B-16.
Corfield Family Album.

Fort Henry, looking south from the north wall, 1917.
National Archives of Canada #C-43233. G.E. Marrison collection.

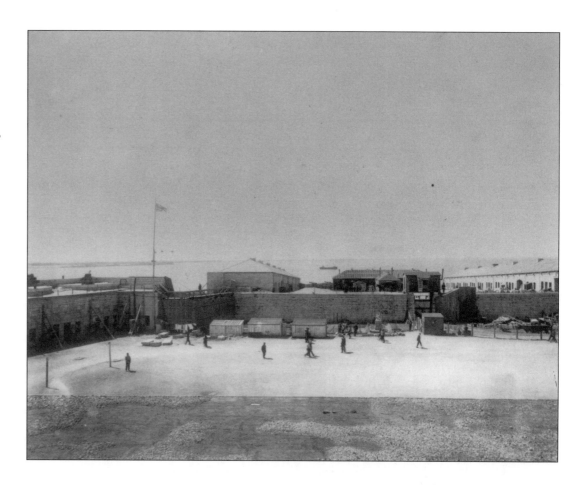

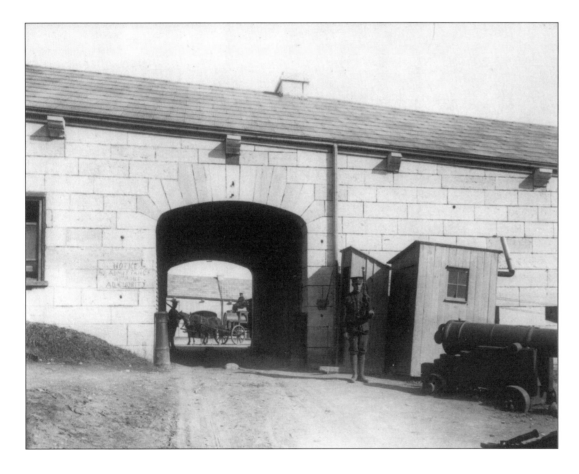

The west entrance into Fort Henry, 1917.
National Archives of Canada #C-43237.
Photographer: G.E. Marrison.

Prisoners' living quarters, Fort Henry, 1917.
National Archives of Canada #C-17324. G.E. Marrison collection.

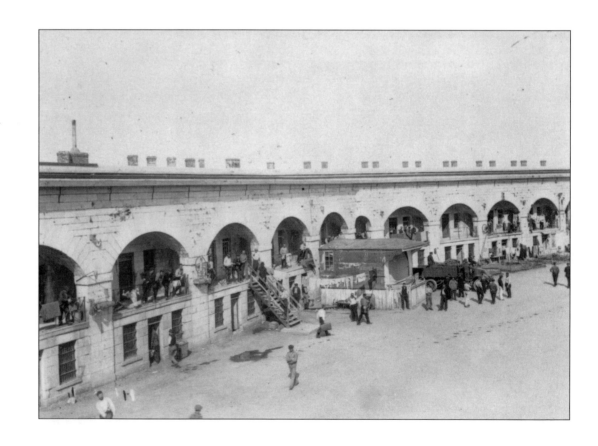

The summer of 1943 was a difficult one for the German prisoners of war interred at Fort Henry. More than three hundred enemy seamen had been living there for almost two years. Twenty prisoners shared each stone-walled room, which had no natural light and poor ventilation. In the spring, these rooms became intolerably damp.

In August, the prisoners went on strike. For nineteen days, they refused to work, prompting the authorities to decrease rations by one-fifth. The management also cut out several privileges, including recreational opportunities such as movie nights and daily walks, for the duration of the strike.

On the evening of August 26, 1943, the prisoners were enjoying one of the first of their reinstated privileges, a concert. Unknown to the guards, several prisoners were using the diversion to escape through an unused sewer system. By passing through the pipes, the prisoners were able to circumvent the thirty-foot-wide moat, as well as the twenty-foot-high, four-foot-thick walls surrounding the compound. In all, nineteen prisoners were reported missing during the evening roll call. Guards immediately began a room by room search, and verified that the missing men had, indeed, escaped.

The first two were recaptured almost immediately, having taken refuge at Deadman's Bay. Some of the prisoners made it as far as Joyceville, and several more were discovered at Seeley's Bay, but by roll call the following evening, sixteen of the escapees had been returned to the fort. The lucky three who eluded immediate capture were picked up near Clayton, in upstate New York, a week later (Henderson, 1986).

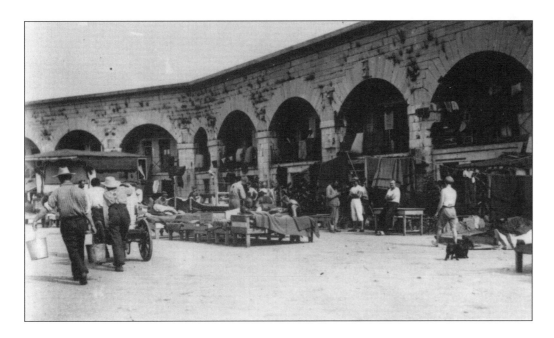

Prisoners interred at Fort Henry during World War I.
Queen's University Archives #PG-K 93-33.

Citizens greeting the Duke and Duchess of Cornwall and York, October 15, 1901.
National Archives of Canada #PA-12009.
Photographer: William James Topley.

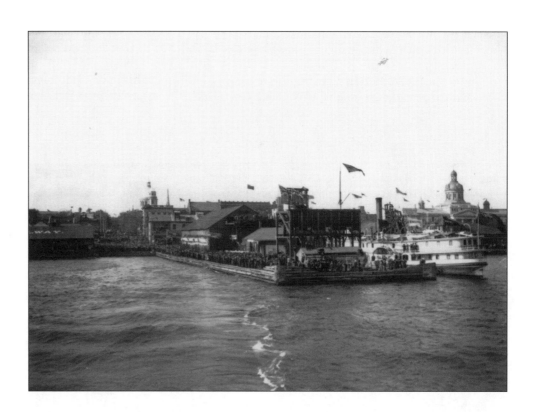

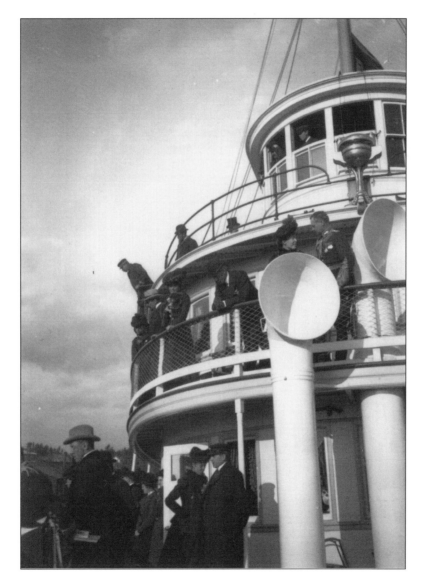

**The Duke and Duchess aboard the steamer
Kingston en route for Brockville, Ontario,
October 15, 1901.**
National Archives of Canada #PA-12010.
Photographer: William James Topley.

Procession of the Royal Party to City Hall, 1901.
National Archives of Canada #PA12007.
Photographer: William James Topley.

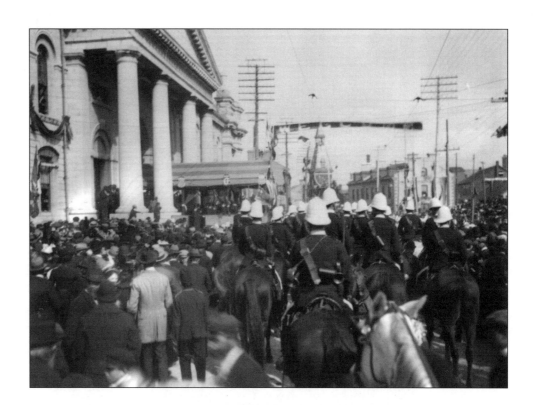

In January 1860, rumours of a proposed royal visit by the Prince of Wales — who was later crowned King Edward VII — began to reach Kingston. These rumours were confirmed by the end of March, and a couple of months later, preparations were well underway to accommodate His Majesty for an overnight stay in September.

The city was in turmoil. Plans were submitted, approved, altered, and resubmitted. Mortonwood and Alwington, where the prince and his entourage were to be billetted, were lavishly decorated for their arrival.

Those not otherwise employed were charged with clearing the streets and sidewalks of greenery, while home and business owners set to in a flurry of tidying, repairing, and painting. Upper-class families outfitted themselves with complete new wardrobes for the two-day visit, and boned up on their etiquette.

Several civic groups vied to construct the most impressive arch along the royal route through town. Unfortunately, the arch built by the members of the Orange Lodge featured their insignia at the apex, which infuriated area Catholics. The ensuing squabble escalated to the point where the royal party decreed that there be no banners or arches of any kind during the visit. The members of the Orange Lodge insisted that not only would their arch remain on display, but on the day of the visit they would march in full regalia, 15,000 strong.

The impasse continued right up until the ship arrived on September 4. The royal party refused to dock due to the demonstration by the Orange Lodge, who had followed through with their intentions. The Prince remained on board the ship and, the following day, set sail without setting foot in Kingston (Roy, 1952).

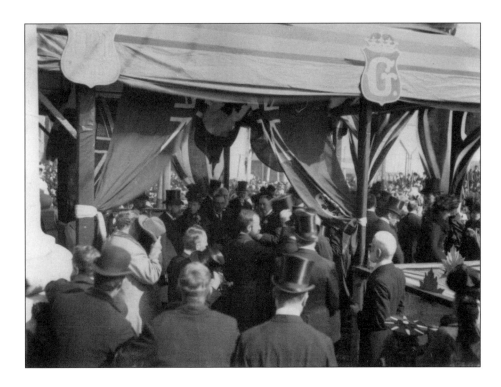

Their Royal Highnesses arriving at the podium, 1901.
National Archives of Canada #PA-12004.
Photographer: William James Topley.

Steamer *Banshee*, 1856.
National Archives of Canada #PA-136186.
Photographer: H.E. Sheldon.

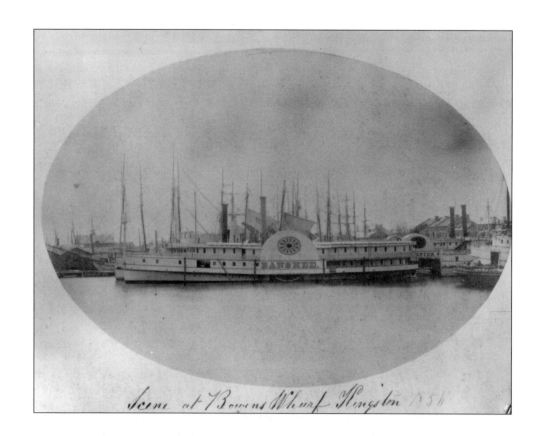

The *Canadian Beaver*, 1920.
National Archives of Canada #PA-135271.
Andrew Merrilees collection.

75

The *Bruce* towing the *Kingston* to the ship graveyard, Garden Island, 1863.
National Archives of Canada #PA-135272.
Photographer: Sheldon and Davis.

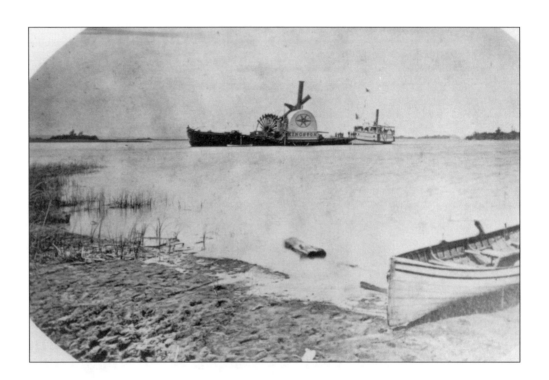

The *Barquee*, September 1891.
*Queen's University Archives #A.ARCH V.23 Boa-
Sail-7.*

A busy day in the harbour, 1929.
National Archives of Canada #PA-56501.
Photographer: C.M. Johnston.

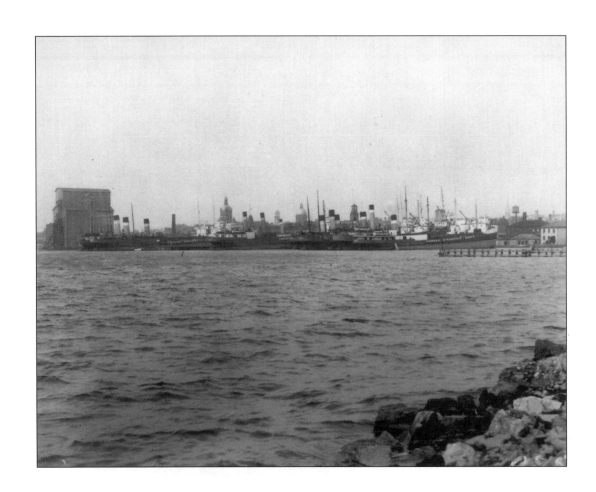

Kingston's place as the premier point for transshipment seemed certain at the beginning of the nineteenth century. Although the big ships could technically sail as far as Prescott before being offloaded, the return was only feasible with a favourable wind.

In September 1916, however, the first steamship to ply the lakes was launched at Finkles Point. The *Frontenac* and the many steamers which followed could safely and reliably go to Prescott and back, which threatened Kingston's lock on the transshipping business. Since they were both more convenient and more comfortable than sailing ships, the steamers did pick up much of the passenger trade. However, it still remained cheaper to send cargo by sail, and thus Kingston kept her status as a major port (Preston, 1954).

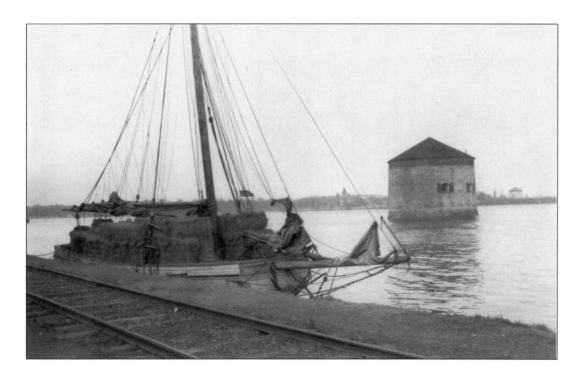

A schooner with a load of hay, 1927.
National Archives of Canada #PA-87601. John Boyd collection.

lthough in more recent years Kingston has been a military centre, a university town, and seat of government, shipping was the city's major industry until the turn of the century. The decline of Kingston's status as a major port, which began in the 1840s with Britain's adoption of a free trade system for the importation of wheat, was followed by a recession in the 1850s.

Although Kingston's businesses had continued to expand in anticipation of increased demand, that demand never materialized. Part of the failure was due to the diversion of wheat through New York. An additional blow came when the British reassigned the forces stationed at Kingston to fortify ports overseas in preparation for the Crimean War in the mid-1850s.

Much in the way of direct revenue was lost by local merchants — both those supplying contracts to the base and those who lost their military clientele. In addition, the market for Canadian timber, much of which was exported through Kingston, was being undercut by an influx of low-cost lumber imported to Great Britain from the Black Sea.

Improvements on the St. Lawrence River also contributed to the Port of Kingston's downfall. Upon completion of deeper canals at Lachine and Cornwall, the remaining sailing ships began to bypass Kingston and proceed directly into the St. Lawrence River. These ships were then towed through the new canals and thus avoided offloading their cargo at Kingston onto smaller boats for the trip down river (Preston, 1954).

The Kingston Road, 1920.
National Archives of Canada #PA-125248.
Photographer: C.H. Heels.

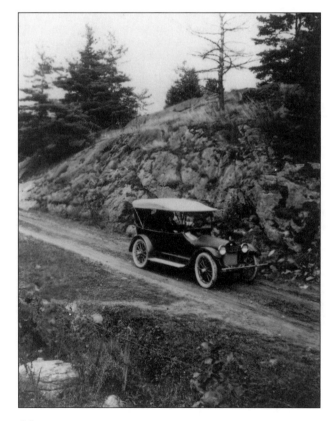

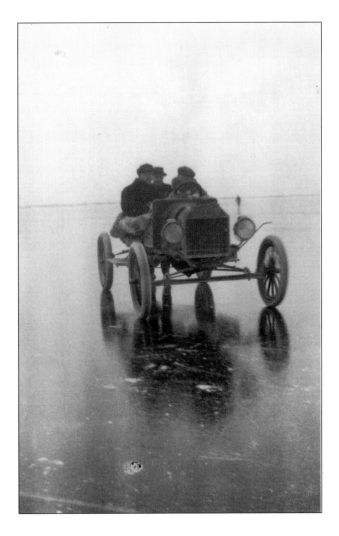

Driving on the ice, c. 1916.
National Archives of Canada # PA-56128.
Photographer: C.M. Johnston.

Wellington Street, c.1920.
National Archives of Canada #C-27715. Marius Barbeau collection.

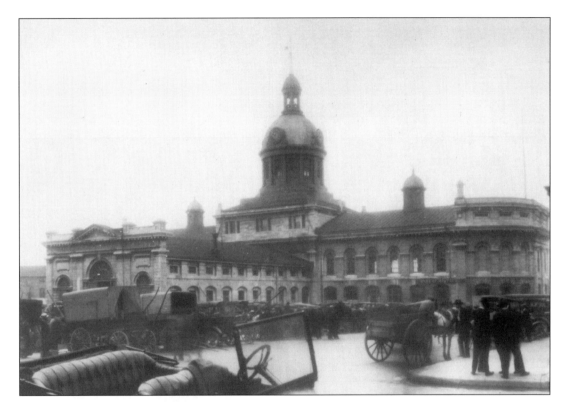

City Hall, c. 1920
National Archives of Canada #C-27717. Marius Barbeau collection.

Post office.
*National Archives of Canada #PA-53151. Canada:
Department of Public Works collection.*

No one knew for certain from whence he came, but from the 1920s onward Dollar Bill was a Kingston original. Born William Allen, Bill started out as a waiter at one the restaurants around campus and soon became a fixture around Queen's. He loved to hang out in the Arts Club Room, holding forth with his particular brand of wisdom.

In addition to helping look after the football team's mascot, Boo Hoo, his zest for living soon made him a favourite of the players. Bill, a renowned gate-crasher, was reputed to travel on the train for free to all the out of town games. He would casually sit chatting with players in their coach until he spied the conductor, then he would step out the door and climb over top of the carriage's roof to the opposite side of the car. When the coast was clear, he would re-enter the coach and resume his seat.

During Kingston's dry years, Bill found a higher calling than the unofficial edification of the student body. A born rebel, Bill began bootlegging liquor to the thirsty citizens of Kingston from an abandoned airplane hangar in Barriefield.

Bill did not distill his own liquor, but had it brought in from Quebec. It was reportedly delivered in the most ingenious ways. Once, Bill used an ambulance to ferry the liquor down from Hull, and another time it was delivered by hearse from Montreal.

Since Bill believed in following the letter of the law, he would not keep his stock of liquor in the bar. However, the Cataraqui River was merely steps away, and afforded both a convenient hiding place and an inexpensive cooler. When necessary, he would don a bathing suit and roller skates to fetch a bottle or two from the chilly depths.

The very soul of discretion, Bill met many of his customers while strolling through town, but never betrayed by so much as the blink of an eye that he knew any one of them. His discretion extended even to those customers who faced him occasionally in court, when, after a raid on his place, he would face the bench and opposing counsel and be fined for following his chosen vocation (Hamilton, 1977).

The original post office building on Princess Street.
National Archives of Canada #C-27709. Sir Arthur G. Doughty collection.

Kingston, Portsmouth and Cataraqui Railway streetcar, 1922.
Queen's University Archives #PG-K 184-10.

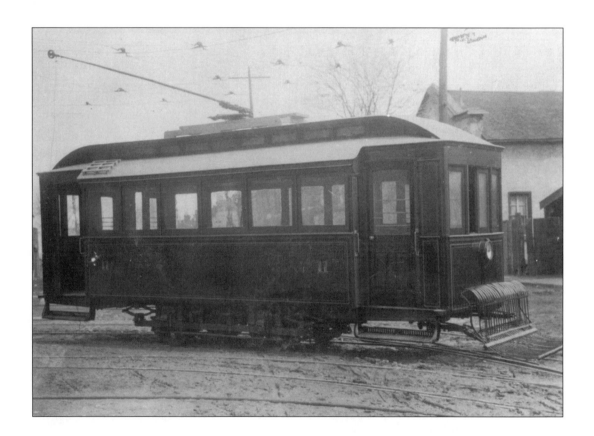

In February of 1877, a horse-drawn streetcar wended its way up Princess Street, the first of many trips. This route became the basis for the Kingston Street Railway, which operated until 1893. At that point, the company was renamed the Kingston, Portsmouth and Cataraqui Street Railway. In September of that year, Kathleen Hardy was at the switch for the first run of the city's new electric car.

The company continued to expand throughout the 1890s. In all, about eight miles of track covered the city, which was serviced by three main routes. The most complex of these was the Portsmouth route, which began on King at Princess Street and zig-zagged along most of the major streets in downtown Kingston before turning around at Rockwood Asylum for the return trip. The other two lines were relatively straightforward. The Belt line served Princess, Alfred, and Union streets, while the Bagot route began at Bagot and Princess, and ran, via James Street, to the outer station on Montreal Road and back. Although a fourth line was originally built along Princess Street to Williamsville (between Victoria and Regent streets), it was discontinued around 1910 due to lack of revenue.

In 1897, the company's name changed again, this time to the Kingston, Portsmouth and Cataraqui Electric Railway. This company continued to run Kingston's streetcars until March 1930, when a fire raced through their Queen Street carhouse, destroying the building along with twenty of the company's streetcars. Since the cost of replacement, $325,000, was beyond the company's scope, the company's contract for passenger service was signed over to Kingston City Coach Lines, ushering an era of buses (Dillon and Thomson, 1994).

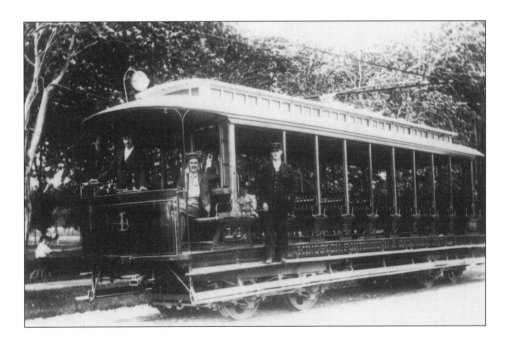

Streetcar #14.
Queen's University Archives #PG-K 184-1A.

87

Grant Hall tower, 1923.
National Archives of Canada #PA-31023.
Photographer: W.J. Bolton.

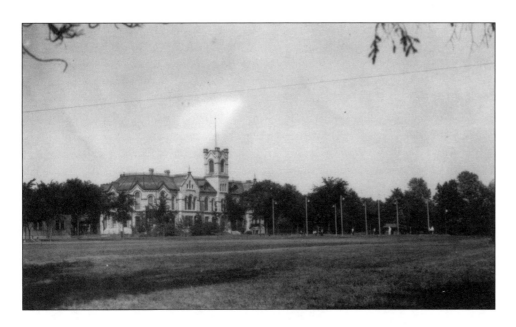

Theology Building, Queen's University, 1923.
National Archives of Canada #PA-31021. Canada: Department of Manpower and Immigration collection.

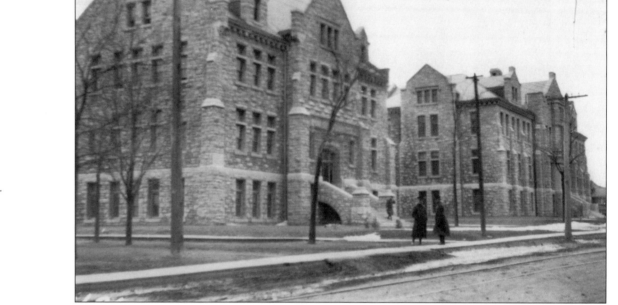

Gordon and Nichols Halls, c. 1916.
National Archives of Canada #PA-56144.
Photographer: C.M. Johnston.

Three circumstances led to the establishment of a medical faculty at Queen's College. The first was a general agreement by the board of trustees, a few months after the first classes in the new college had begun, that such a faculty would be an asset.

The second circumstance was that eight of the medical students about to begin their final year at Trinity College in Toronto discovered that, in order to graduate, they must convert to the Anglican faith. These students, with the blessing of their dean, then petitioned Queen's to establish a more liberal medical school. The dean suggested that these transfer students be given full credit for their work at Trinity.

The third circumstance was that the vast majority of the town's physicians thought that a medical school would greatly benefit the community. And so a faculty was put together, under the presidency of Dr. James Sampson, the surgeon at Kingston Penitentiary.

The lone dissenting voice among all the local physicians was that of Dr. John Stewart, who agreed to act as secretary of the new faculty and teach anatomy. Stewart's criticisms would continue to plague the fledgling organization for many years to come.

These founders of the medical faculty agreed to begin on a temporary basis, as lecturers, with only the compensation of their student's fees. For subsequent years, the board would petition the government for a grant to cover the costs of this new endeavour, but that first school year of 1854–55 the board shelled out only £250 to cover expenses.

In the spring of 1855, the temporary lecturers were given full professorships. That same year, the faculty petitioned the board for a building of their own. Not an outrageous request, given the number of students the department drew to the college, but to the financially overextended board it seemed quite out of the question.

The second year of its operation, the medical school moved from its location on Princess Street onto the campus proper. Classes were divided between the east block basement and two of the rooms in Summerhill. Although the faculty had a lot more space, quarters were still cramped as the student body had more than doubled to forty-seven. This comprised more than the combined enrollment of the Arts and Theology departments. By 1859, Queen's had capitulated to the request for more space, and erected a separate building for the medical faculty.

Throughout these early years, Stewart continued to harass his colleagues, most of whom he detested. When Sampson, the faculty president, died in 1862, Stewart applied for his post at Kingston Penitentiary. When his chief rival for the position passed out leaflets extolling his own virtues, Stewart countered by printing rebuttals in the *Argus*, his self-published newspaper. As Stewart's ire rose over the contest for the vacant position, he began to rant about his colleagues on the faculty as well.

Finally things came to a head when the board first suspended Stewart, and then, when he could not defend himself adequately on the charges of defamation of character and insubordination, fired him. Subsequently, one of the slandered faculty won a libel suit against Stewart, who was jailed as a result.

In 1866, the board of trustees demanded that faculty members subscribe

to the *Westminster Confession of Faith*. This so outraged the majority of the professors that they immediately severed all ties with Queen's College. With the help of John A. Macdonald, they invested themselves in a new charter under the title of the Royal College of Physicians and Surgeons of Kingston.

The new college had its share of troubles. The government grant proved inadequate to support the faculty, and they changed residences several times in an attempt to find adequate room. Enrollment plummeted, and the students no longer had access to the facilities at Queen's.

The departure of the medical faculty, although difficult, served to temper the attitudes of the members of the board of trustees, who had previously acted with impunity. New, more liberal statutes were drawn up at Queen's, opening the door for a reconciliation with its wayward department. In 1880, the faculty returned to campus, and a dozen years later, the Royal College of Physicians and Surgeons merged with Queen's to begin anew as the Faculty of Medicine (Gundy, 1955).

Queen's University.
National Archives of Canada #PA-43617. Canada: Department of the Interior collection.

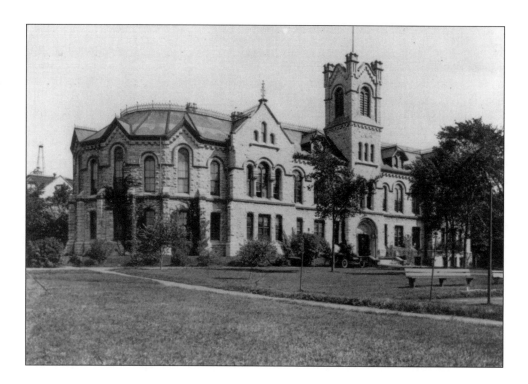

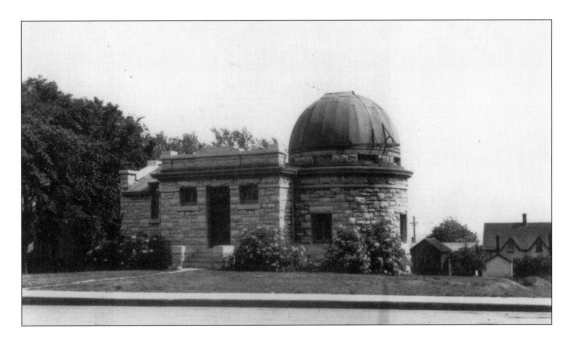

Observatory, Queen's University, 1923.
National Archives of Canada #PA-31022.
Photographer: W.J. Bolton.

Although the military had long desired an observatory in the area, both to fix longitude accurately and to determine the correct time, it was not until the solar eclipse in May 1854, that sufficient public opinion could be rallied to build one. Local business owners donated $800 toward the scheme, and this money was used to buy a telescope. While the equipment arrived only a few months later, it could not be erected until construction of the dome was completed the following spring (Hughes, 1986).

Division Street, 1929.
Queen's University Archives #PG-K 125B-1.

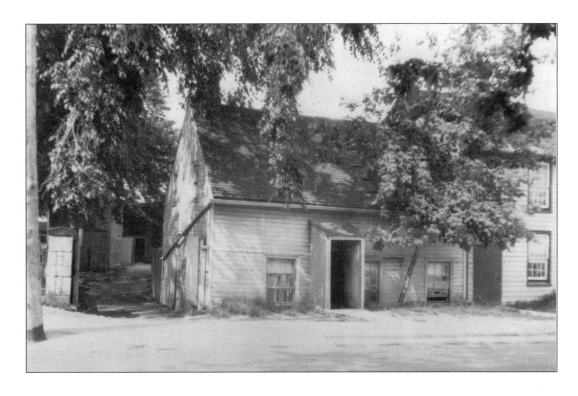

Simcoe House, Queen Street, 1924.
National Archives of Canada #PA-86781. John Boyd collection.

Simcoe House.
Queen's University Archives #PG-K 103-2.

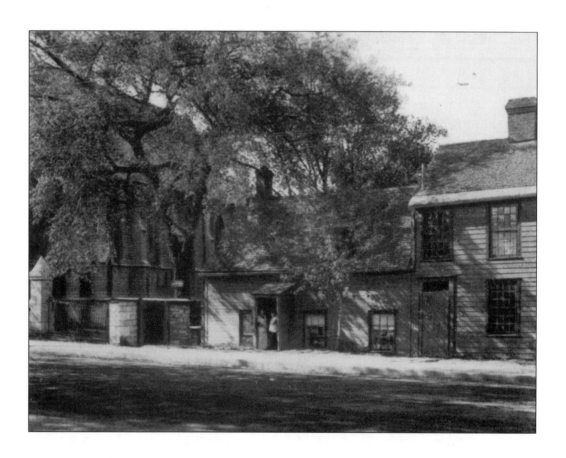

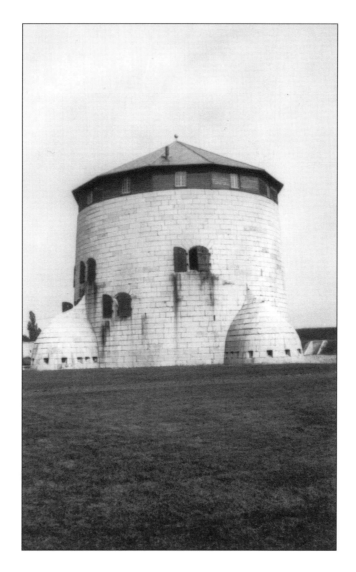

Fort Frederick, 1924.
National Archives of Canada #PA-86784. John Boyd collection.

Barracks at Fort Frontenac.
National Archives of Canada #C-22938. R.G. Parker collection.

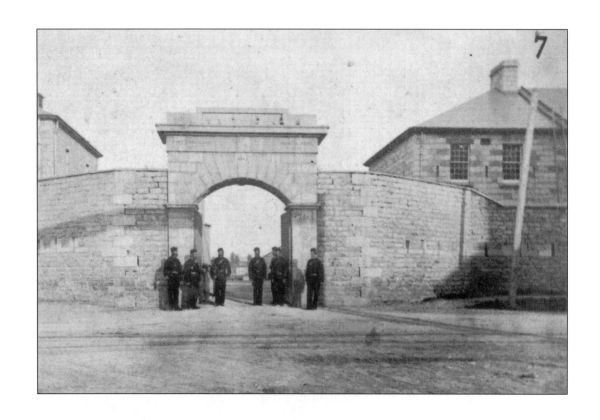

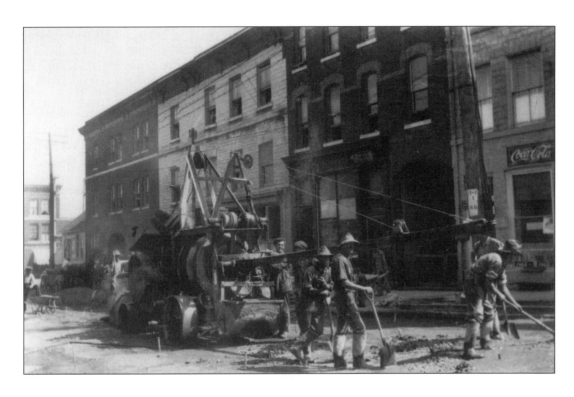

Road repairs, 1923.
Queen's University Archives #PG-K 197B-9.
Corfield Family Album.

In 1789 the governor of Canada, Sir Guy Carleton, Lord Dorchester, decided to split the administration of the colony. Carleton appointed General John Graves Simcoe as lieutenant-governor of the new province of Upper Canada (Machar, 1907) a full year before the Canada Act was passed in 1791. Simcoe arranged for passage to Canada in the fall of 1791, as he was to begin his term on September 12. However, two members of his executive council received permission to winter in England instead of immediately departing for Canada. Because of this, it proved impossible to assemble a quorum, and Simcoe's appointment could not be properly ratified.

Instead of completing his journey to Upper Canada, where it would soon become apparent that he did not have the authority to govern, Simcoe spent the winter in Lower Canada. The two errant councillors arrived in Quebec at the beginning of June 1792, so Simcoe himself left Montreal on the twenty-second. He finally arrived at Kingston on July 1, 1792, two full years after he had been chosen as lieutenant-governor (Cruikshank, 1924).

Upon his inauguration at Kingston in July 1792, Simcoe immediately set about preparing the province for its new government.

As his initial base of operations at Kingston, Simcoe had a small wood-frame house on Queen Street, which later came to be known as Simcoe House. Although Simcoe did much of his preparatory work at Kingston that summer, he initially chose Newark, later named Niagara and subsequently renamed Niagara-on-the-Lake, as his capital. The town would have to wait almost half a century to realize its dream of becoming capital (Machar, 1907).

Mouldey Brothers brickyard.
Queen's University Archives #PG-K 163-9A.

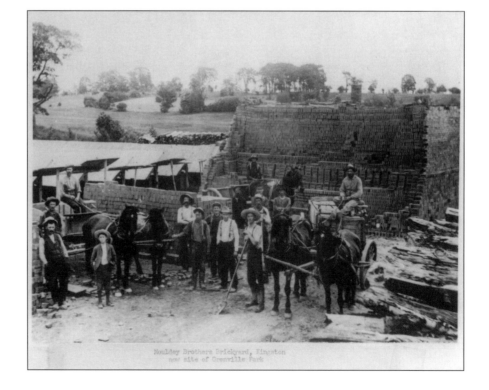

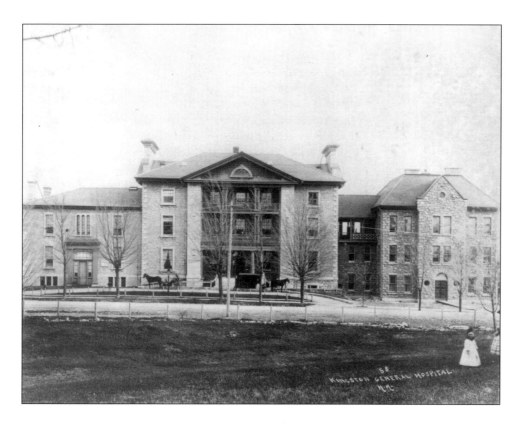

Kingston General Hospital.
National Archives of Canada #C-5494.

Charles Edward Poulett Thomson was born in England in 1799. First elected to the British Parliament when he was in his late twenties, it wasn't until the summer of 1839 that he became governor general of Upper and Lower Canada.

He travelled to the colonies in the fall of that year and, by January 1840, had overseen the passing of resolutions declaring a union between Upper and Lower Canada in the legislative assemblies of both provinces. Thomson declared the two provinces united on February 10, 1841, and five days later he announced that the united Parliament would meet in Kingston. The Crown rewarded Thomson's hard work with the title Baron Sydenham of Sydenham in Kent and of Toronto in Canada.

The governor general arrived in Kingston on May 28, 1841, and proceeded with his party past the assembled citizens of Kingston to his official residence at Alwington House. Thomson loved his new home, finding it delightfully peaceful and quiet after the hustle and bustle of Montreal.

The first sessions of the legislative council and legislative assembly met at noon on Monday, June 14, 1841, in the new Parliament building. Although built to house the General Hospital, the building had never been used as such. It, along with the new marine railway building, housed the parliamentary chambers as well as all the government offices.

Throughout the summer Thomson continued throughout the summer to coach his new members of Parliament on the finer points of government.

Early difficulties abounded, not only because of the MPs' unfamiliarity with procedure, but also because about a third of the seats were being contested. This necessitated some absences from the House and made it difficult to form a quorum.

On Saturday, September 4, Thomson went riding. As he was returning to Alwington House for dinner, his horse tripped and fell, throwing him to the ground. The horse then recovered its feet and, making off toward the stable, dragged Thomson quite a distance by his foot, which was caught in the stirrup. Eventually, the stirrup loosened, and Thomson was carried home by two labourers who happened upon him.

His injuries were not extensive; a broken bone just above the ankle from the fall, and a deep, gravel-filled cut on his knee where the horse had dragged him. The doctors who treated him believed he would make a full recovery, set his leg, and ordered bed rest.

Unfortunately, the doctors had no way of knowing that the wound was infected with tetanus. Characterized by a gradual paralysis of the muscles, the disease is almost always fatal to those who contract it.

For the first ten days or so, it seemed Thomson would recover. Although he was weak, everyone agreed that this was due to his confinement to bed. By the end of the second week after his accident, it was obvious to all that the end was near. On Saturday, September 18, his facial paralysis was so pronounced he was unable to eat. He died at seven the following morning (Angus, 1967).

Hospital, 1927.
National Archives of Canada #PA-87849. John Boyd collection.

Parapet wall of the moat around Murney Tower, July 1934.
National Archives of Canada # PA-35574.
Canada: Department of National Defence collection.

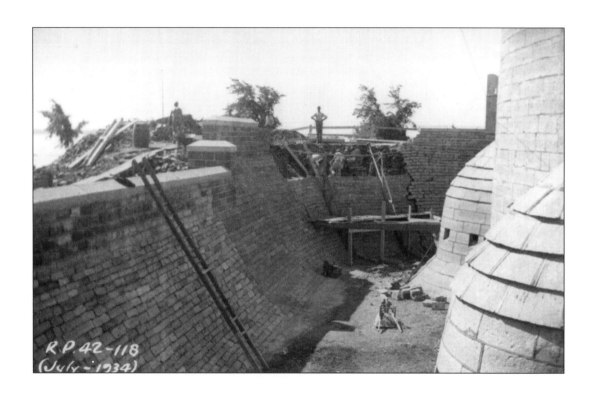

The Martello Towers were originally built between 1846 and 1848 to protect both the Rideau Canal and Kingston harbour from a possible American attack. Built in response to the threat the American ideal of manifest destiny posed to British expansion westward, the four towers were part of a $4-million effort to improve the colony's defences (Stanley, 1950). The U.S. continued to push its claim to the entire west coast until distracted by the war with Mexico in the 1840s (Moorehead, 1981).

Like any feat of engineering in the nineteenth century, the endeavour was not without its problems. After a long day's labour on the Cathcart Tower on Cedar Island, eighteen men were returning to the mainland when they were drowned in Hamilton Cove. Three more men perished in the same bay the next day while searching for their comrades' bodies. The spot was subsequently known as Deadman's Bay because of the tragedies.

Construction of the Victoria Tower, also known as the Shoal Tower because it was built in the actual harbour, posed the greatest difficulty. During the winter, labourers built a dam on the ice. Once the ice melted, the dam settled on the bottom of the lake, and the water which filled it was pumped out. Once the interior was dry, the foundation of the actual tower was built inside.

The third tower, that at Fort Frederick, was erected on the site of the original battery built about 1791 to defend early Kingston (Stanley and Preston, 1950).

The fourth tower, Murney Tower, was used for many years as a barracks for married men and their families. Although staffed by a single soldier during the Crimean War in the mid-1850s, its usual complement of about seven families doubled to fourteen during the 1860s when tensions between Britain and the States increased (Moorehead, 1987).

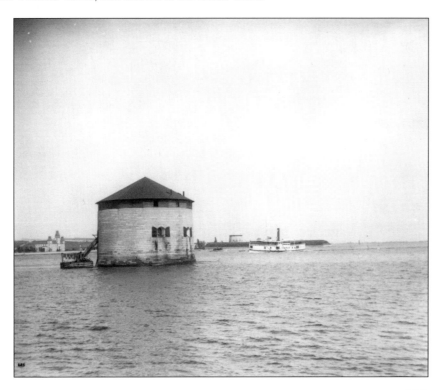

Martello Towers, 1915.
National Archives of Canada #PA-8887.
Photographer: William James Topley.

Princess Street looking east from the Grand, c. 1930.
Queen's University Archives #PG-K 128-25A.

For six months after the old Opera House burned down, rumours flew about where the new building would be situated. Each potential investor favoured different locations for different reasons. Since none of these speculators could agree, plans for rebuilding the facility stalled. Eventually, some of the leading citizens of the day banded together to form The Grand Opera House Company of Kingston Ltd. The company issued six hundred shares at fifty cents a piece to raise the $30,000 needed to start building. Six months after the company was formed, the executive decided to rebuild on the site of the old Opera House, and the company purchased the lot, along with frontage on Princess Street, for $13,000.

Infighting among local parties led to multiple delays, but building finally got under way in September 1901. Construction crews worked around the clock to complete the work in time for the grand opening on January 14, 1902.

Throughout the early part of the twentieth century, many fine touring companies performed at the Grand. Eventually, the costs outstripped the revenues generated by live performances. In May 1938, the Grand was turned into a movie house. After almost a quarter century of screening new releases, the Grand was in danger of being paved over in 1961. Through the actions of several concerned citizens, this fate was averted. Renovations were made, and in the spring of 1967, the facility was re-opened as a civic auditorium (Waldhauer, 1979).

Princess Street looking east from Wellington, c. 1930s.
Queen's University Archives #PG-K 128-3D.

**Tollhouse on the old Cataraqui Bridge,
c. 1930.**
*National Archives of Canada #C-27725. Sir Arthur
G. Doughty collection.*

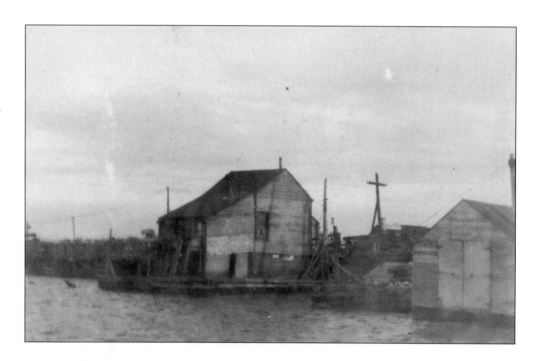

Almost from the beginning of the British takeover of the Kingston area, there has been a need for a bridge over the Cataraqui River. With the military installations east of the river separated from the business centre on the west bank, a bridge spanning the Cataraqui seemed inevitable. The War of 1812 highlighted this need, as the population swelled from three hundred to over two thousand in less than five years.

On August 7, 1826, concerned citizens met at the Court House to establish a committee to oversee construction of the proposed bridge. The military had agreed to pay £300 per year in exchange for free passage of all military personnel, employees, stores, and livestock across the new span. Buoyed by the assurance of this lucrative annual contract, the committee had no trouble in selling all of the 240 shares needed to raise the £6,000 capital needed to build the bridge. In fact, the shares were sold out within half an hour, an amazing feat considering that the value raised, when projecting today's rates onto labourers' wages of the period, was about a million dollars.

Tenders for construction of the bridge were called for in May 1827. Construction was completed over the next two years, and the bridge was opened, in a limited capacity, in July 1829.

Initially, the fares were high. A horse and rider could expect to pay five pence to cross one way, while a pedestrian was charged two pence. Farmers with livestock were charged two-and-a-half pence for every large animal, such as horses, cattle, and oxen, in his herd. Smaller animals, such as pigs, goats, and sheep, cost the farmer a penny each. Fares were halved on Sundays to allow residents of the east side of the river to cross to their churches in town.

This state of affairs continued for about fifteen years, until, in the mid 1840s, the company undertook to reduce its fares by half in an attempt to increase usage. Thus, the fare for a single pedestrian was dropped to a penny. Forever afterward, even after usage became free of charge, the name "Penny Bridge" remained (Grenville, 1995).

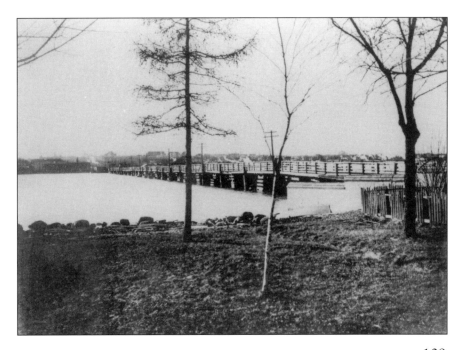

Penny Bridge.
Queen's University Archives #A.ARCH V.23 Bri-Cat-1.

Warden's residence, Kingston Penitentiary.
National Archives of Canada #PA-46245. Canada: Department of Public Works collection.

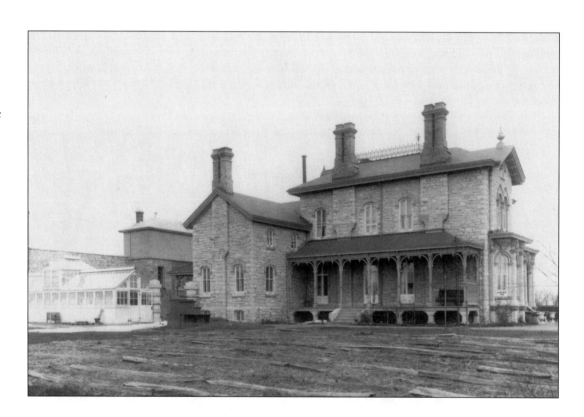

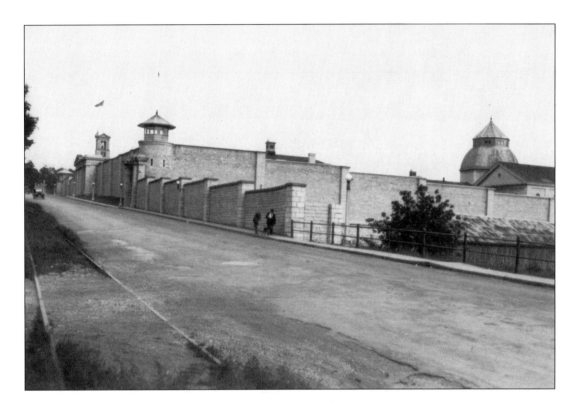

Kingston Penitentiary, 1930.
National Archives of Canada #PA-89830. John Boyd collection.

Main entrance, Kingston Penitentiary.
National Archives of Canada #PA-46244. Canada:
Department of Public Works collection.

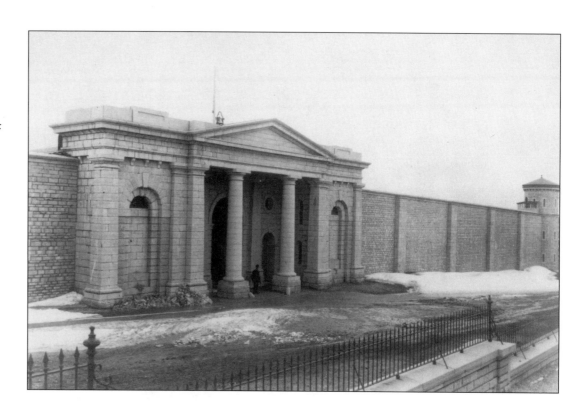

Kingston Penitentiary was built in the 1830s on less than one-tenth of the one-hundred-acre plot of land purchased for its construction. The penitentiary was initially pressed into service on June 1, 1835, when the first six inmates were transferred there. By the following year, the prison's population had risen to sixty-two. Although mainly men, the prison population included both women and children as well.

The prison was run strictly according to the rules and regulations set forth in 1836. Inmates were not allowed any contact with each other at all. Prisoners were forbidden to speak to each other, nor were prisoners allowed to gesture or even look at each other. They were expected to obey any directive given by their keepers instantly, with "perfect obedience and submission" (*Rules and Regulations of Kingston Penitentiary*, cited in Edmison, 1954:28). Infractions would be dealt with by immediate corporal punishment.

The rules spelled out the duties of the staff just as clearly. While the guards worked from sunrise to sunset, seven days a week, through most of the year, the warden was expected to be on duty around the clock.

The penitentiary's beginnings under Warden Henry Smith Sr. seemed benign enough, perhaps in part due to the endorsement given by Charles Dickens, who toured the place a decade after its inauguration and considered it "intelligently and humanely run" (Dickens, *American Notes*, cited in Edmison, 1954:30). Soon it became evident that all was not as it should be at the prison. Smith began to have many disagreements with his subordinates, particularly the surgeon, the chaplain, and the architect of the prison.

Smith also had two sons, one of whom, Henry Smith Jr., had a seat in Parliament. The MP was able to raise his father's salary, and at the same time decrease the salaries of the warden's three principal opponents and many of the staff who spoke out against conditions at the prison.

Smith's other son worked under him at the prison. Apparently this son had a sadistic streak which he liked to vent by dousing inmates with water. He also enjoyed shooting with a bow and arrows, and it appears that he sometimes used prisoners for target practice.

Conditions continued to deteriorate at the prison until complaints by the prison's surgeon, Dr. James Sampson, resulted in the formation of a commission of inquiry in 1849. The commission, headed by George Brown,

delved into all aspects of the running of the prison, and discovered all manner of corruption and cruelty.

The report was especially critical of the treatment of children incarcerated at the facility. Because even the most minor infractions of the rules, such as laughing or winking, were severely punished by the staff, children as young as eight were often publicly flogged in front of the other five hundred prisoners (Edmison, 1954).

As a result of their findings, the commission proposed a separate facility for incarcerating children, as well as the expulsion of many of the cruel and dishonest staff, including Warden Smith (Roy, 1952).

East view of Kingston Penitentiary.
National Archives of Canada #PA-46242. Canada: Department of Public Works collection.

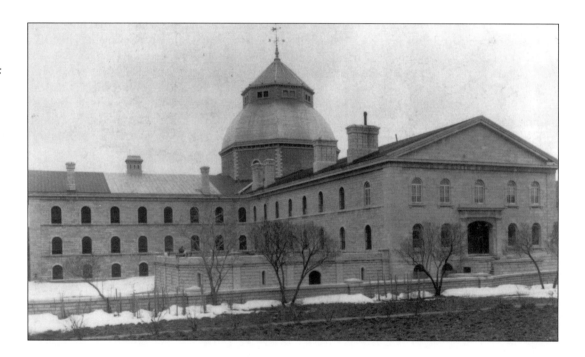

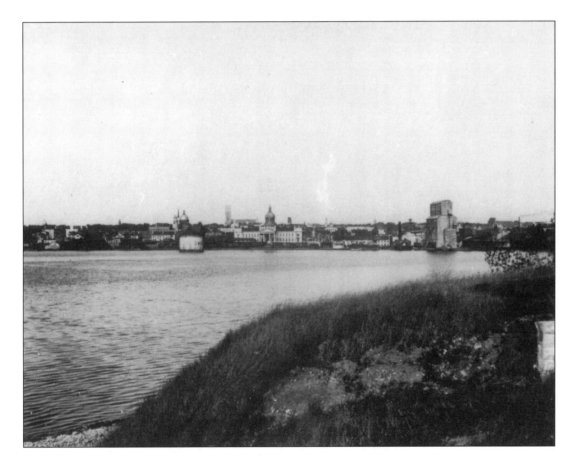

Kingston waterfront from Fort Henry, 1920.
Queen's University Archives #PG-K 132-29.

On the waterfront, c. 1930s.
Queen's University Archives #PG-K 120-27.

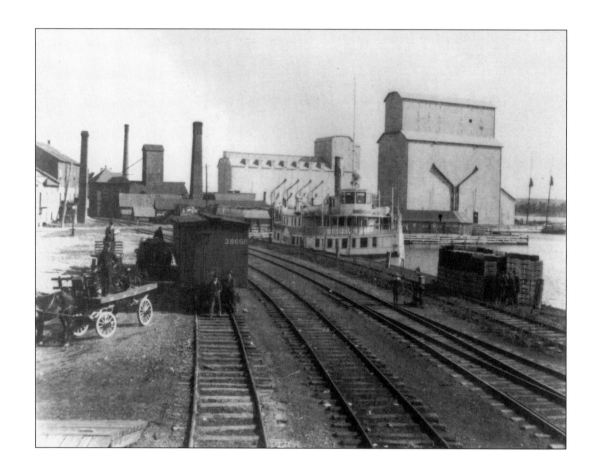

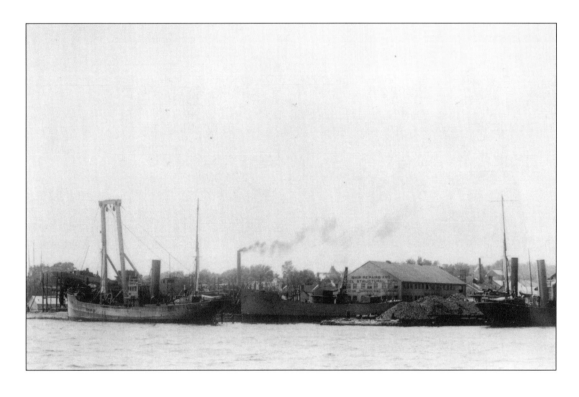

Kingston harbour, c. 1930s.
Queen's University Archives #PG-K 120-24.

Grain elevator, 1930.
National Archives of Canada #PA-56458.
Photographer: C.M. Johnston.

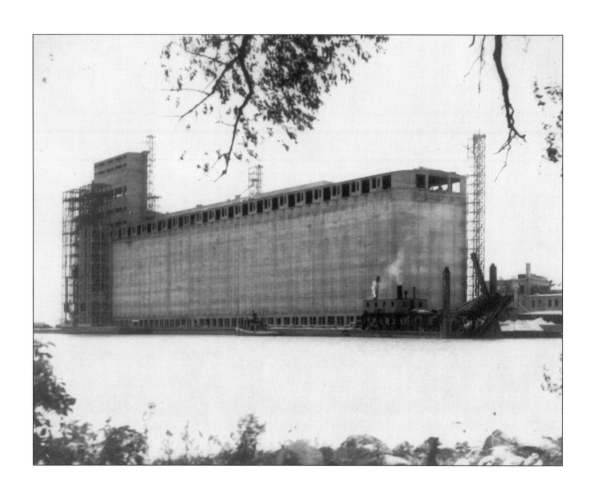

Market Square.
National Archives of Canada #C-27720. R.G. Parker collection.

The greater part of Kingston's expansion after the War of 1812 was due to the British wheat trade. From 1825 onwards, Canadian wheat, including that grown in the States and milled in Canada, poured through Kingston on its way to Great Britain. Even the one-shilling-per-bushel duty charged by the British government on wheat from the colonies couldn't stem the flow (Preston, 1954).

James Richardson, a tailor born in Ireland in 1823, found himself in a position to take advantage of this boom. In September 1857, Richardson gave up his tailor shop to pursue a career in grain forwarding full-time. He established his firm, James Richardson and Sons Ltd., to co-ordinate a fleet of independently owned boats, which plied the waters of the Great Lakes. When that venture proved successful Richardson built several ships of his own to supplement the carrying capacity of his independent contractors. In 1868, Richardson secured the title to the old Commercial Wharf and used the extensive waterfront plot as a base of operations for his fleet. He also built a series of grain elevators. Although Richardson's initial success came in grain forwarding, the company did not limit itself to that commodity. Like other successful ventures, Richardson diversified, soon transporting not only grain but minerals as well (Osborne and Swainson, 1988).

The wheat boom continued until mid-century, when Britain adopted a free trade system in place of its old colonial system. While the latter had ensured that grain from North America would follow the St. Lawrence to Montreal and then to Britain, the former meant that market forces could dictate the trade route. Those forces favoured New York as the point of departure from the new world, partly because the harbour was open year round instead of being ice-bound each winter (Preston, 1954).

Kingston Market, c. 1940s.
Queen's University Archives #PG-K 121-7.

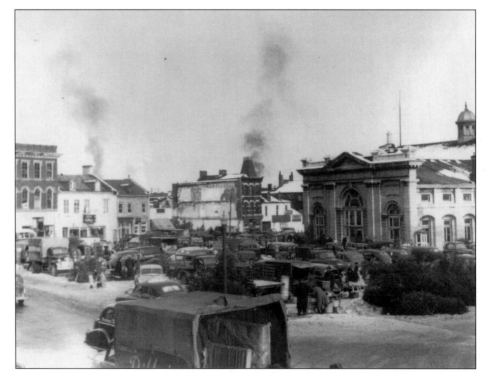

120

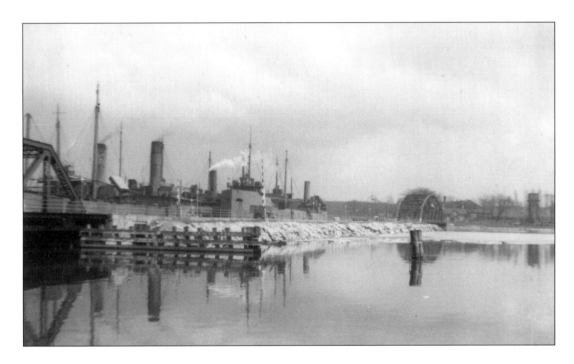

The LaSalle Causeway, 1941.
National Archives of Canada #PA-52617. Canada: Department of Public Works collection.

Atop the LaSalle Causeway, 1940.
National Archives of Canada #PA-52616. Canada:
Department of Public Works collection.

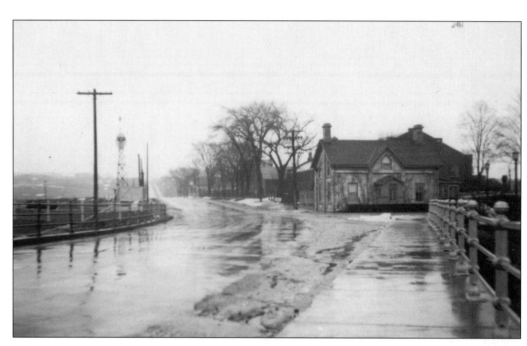

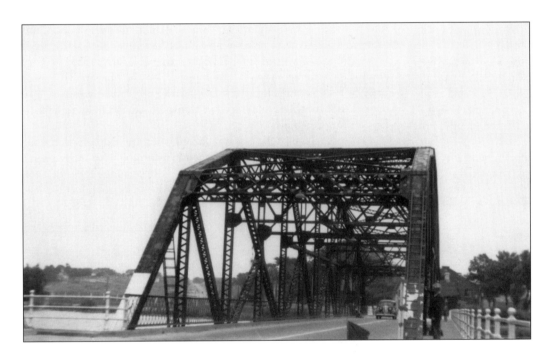

Bridge on the LaSalle Causeway, 1940.
National Archives of Canada #PA-52615. Canada: Department of Public Works collection.

Robert Cavalier, who would later become Sieur de la Salle, was born in France in 1643. At the age of 17, he joined the Jesuits, but found the life too restrictive for his restive soul. Possessed of the heart of an explorer, La Salle came to Canada and first settled in Lachine. Still restless, he gave up his tract of land and travelled west as far as the Illinois and Ohio rivers around 1670.

Thus began La Salle's preoccupation with French expansion westward. In order to further this aim, La Salle proposed building a series of forts westward across the Great Lakes and all the way down the Mississippi River.

The first of these forts was Fort Frontenac, named for La Salle's patron and governor of Canada, Count Frontenac. In July 1673, La Salle and Frontenac, accompanied by an engineer, two hundred troops, and enough labourers to make short work of erecting the fort, landed at the mouth of the Cataraqui River and set to work.

The engineer traced out the plans for the fort, a wooden picket palisade, and work progressed quickly. Once the fort was completed – in just six days – Frontenac returned to Montreal.

La Salle stayed on at Cataraqui, and, in 1674, he travelled to France.

He returned from the court of King Louis XIV with a grant entitling him to Fort Frontenac and its surrounding lands. La Salle immediately began making improvements to his domain. He rebuilt the fort, this time using stone for part of it. He also established a chapel and built lodging for the two Recolet brothers who ministered there.

In the late 1670s, La Salle travelled once again to court. This time he returned with a writ, empowering him to explore westwards and southwards to try to find Mexico, and to establish forts wherever he saw the need.

Cataraqui saw little of La Salle after that (Hagarty, 1953). Upon establishing a temporary base at Chippewa, on the Niagara River near Lake Erie, La Salle commissioned the *Griffon*, the first sailing vessel to ply the upper lakes. In it, La Salle hoped to transport enough hides to finance his expeditions westward.

Fortunately, La Salle was not aboard when the ship was lost with all hands in 1679 during a fierce storm while returning from her maiden voyage (Bourrie, 1995). Despite this setback, La Salle continued his quest for the route to Mexico. Unfortunately, he was to die unsuccessful, at the age of 43, in Louisiana (Hagarty, 1953).

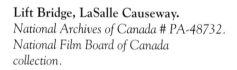

Lift Bridge, LaSalle Causeway.
National Archives of Canada # PA-48732.
National Film Board of Canada
collection.

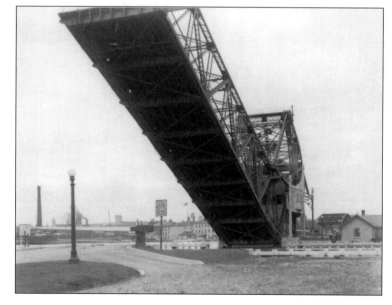

Kingston drydock, 1919.
National Archives of Canada #PA-136185.
Andrew Merrilees collection.

The first ship built by Richard Cartwright in Kingston was the *Lady Dorchester*, launched in 1789. She was followed in 1808 by both the *Governor Simcoe* and the *Elizabeth* (Preston, 1954).

Corvette in drydock, 1943.
National Archives of Canada #PA-52613. Canada: Department of Public Works collection.

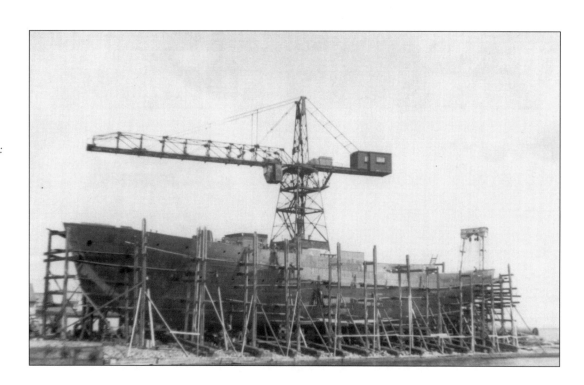

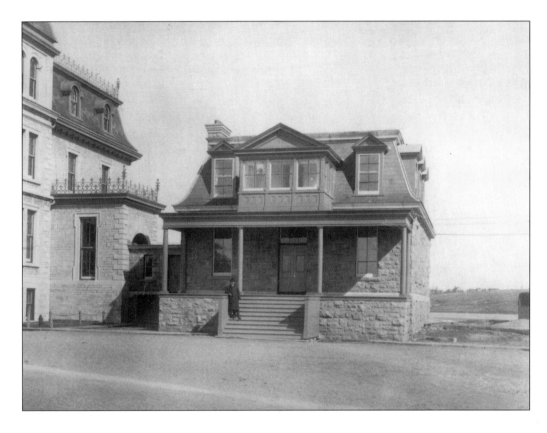

Royal Military College hospital.
National Archives of Canada #PA-53191.
Photographer: Henderson.

Royal Military College, 1880.
National Archives of Canada #PA-143011.
Ross Roxburgh collection.

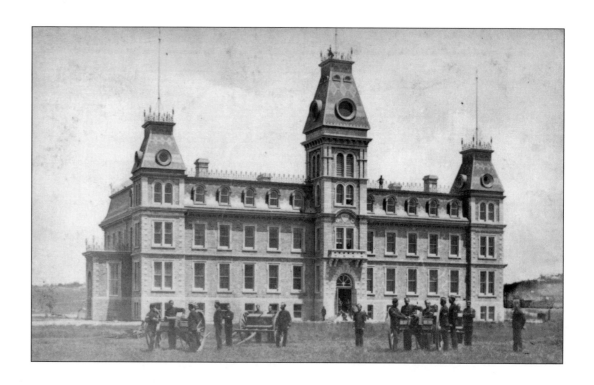

Pier at the Royal Military College, 1942.
National Archives of Canada # PA-52624.
Canada: Department of Public Works collection.

Royal Military College harbour.
National Archives of Canada #PA-52625. Canada:
Department of Public Works collection.

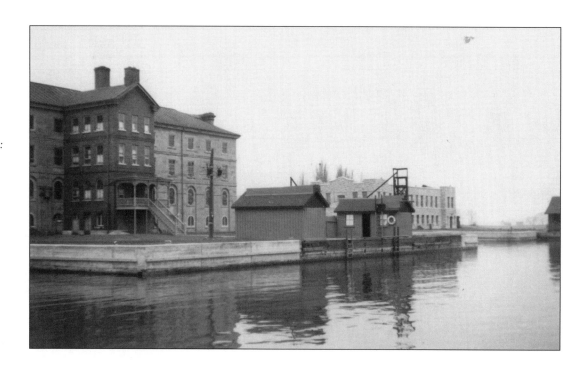

Long jumping, Barriefield, August 1933.
National Archives of Canada # PA-35551.
Canada: Department of National Defence
collection.

Lacrosse team, Barriefield, August 1933.
National Archives of Canada #PA-35581. Canada:
Department of National Defence collection.

Pole vaulting, Barriefield, August 1933.
National Archives of Canada #PA-35549. Canada: Department of National Defence collection.

U pon the withdrawal of British forces from Canada three years after Confederation, the government realized the defence of the country could not be left to the militia alone. The most pressing need was obviously for officers qualified to lead the new regular force.

Kingston was an obvious choice for the establishment of a military college. One of the oldest military installations in Ontario, Kingston already had the empty Stone Frigate, which could be used for classes until a new structure was built. It also had ample space in which to erect whatever buildings were necessary to house the new college.

The first class, comprising eighteen cadets, arrived June 1, 1876. As nothing at the college was ready yet, they spent the first few weeks out on field exercises (Stanley and Preston, 1950).

Royal Military College cadets playing soccer, October 1951.
National Archives of Canada #PA-125423.
Canada: Department of National Defence collection.

Wrecked carriages at Kingston station, August 10, 1947.
Queen's University Archives #PG-K 182-65B.

At 6:30 on the evening of August 10, 1947, passengers waiting at Kingston station to board train number 15, Toronto-bound from Ottawa, were startled to see its engine, number 5702, hurtling towards them at one hundred kilometres per hour. The crowd scrambled to get away as the engine, taking the final turn much too fast, jumped the tracks and flipped, coming to rest on its side directly in front of the station. The stress snapped the engine's coupling to the first carriage, preventing the other carriages from rolling. The first four cars sped past the overturned engine, coming to a stop on the bare road bed. Another four carriages derailed while the final four remained on the track.

The force of the crash tore up one hundred metres of track, toppled the water tower, and scattered debris and steam over a wide area. Once the heat had dissipated, the resulting condensation left five centimetres of water on the station floor.

Trains were routed onto sidings to bypass the wreck all evening. Crews from Brockville and Montreal worked frantically to remove the train and repair the damage. Thanks to their unflagging efforts, normal service was restored in a matter of hours.

Although two crew aboard the engine were scalded to death in the accident, only minor injuries occurred among onlookers or passengers (*The Kingston Whig-Standard*, 1947).

Train wreck, Kingston station, August 10, 1947.
Queen's University Archives #PG-K 182-63B.

References

125 Years Keeping People Healthy: Kingston Psychiatric Hospital.
Kingston: Kingston Psychiatric Hospital, 1981.

Angus, Margaret. "Lord Sydenham's one hundred and fifteen days in
Kingston." *Historic Kingston*. Kingston Historical Society, 15:37-49,
1967.

Bennett, Carol, and D.W. McCuaig. *In Search of the K and P: the Story
of the Kingston and Pembroke Railway*. Renfrew: Renfrew Advance
Limited, 1981.

Bourrie, Mark. *Ninety Fathoms Down: Canadian Stories of the Great
Lakes*. Toronto: Hounslow Press, 1995.

Bourrie, Mark D. Personal communication. 1998.

Cruikshank, E.A. "The first session of the executive council of Upper
Canada, held in Kingston July 8 to July 21, 1792." *Papers and Records*.
Ontario Historical Society, 21:160-170, 1924.

Dillon, George and William Thomson. *Kingston, Portsmouth and
Cataraqui Electric Railway: History of the Limestone City's Streetcar
System*. Kingston: The Kingston Division of the Canadian Railroad
Historical Association, 1994.

Edmison, J. "The History of Kingston Penitentiary." *Historic Kingston*.
Kingston Historical Society, 3:26-35, 1954.

Grass, Donald E. "Michael Grass and the Grass Family of Kingston."
Historic Kingston. Kingston Historical Society, 12:6-10, 1964.

Grenville, John H. "Across the Cataraqui River: A History of the

Penny Bridge." *Historic Kingston*. Kingston Historical Society, 43:34-
54, 1995.

Gundy, H. Pearson. "Growing Pains: The early history of Queen's
Medical Faculty." *Historic Kingston*. Kingston Historical Society, 4:14-
25, 1955.

Hagarty, W.G. "Fort Frontenac." *Historic Kingston*. Kingston
Historical Society, 2:14-25, 1953.

Hamilton, Herb. *Queen's Queen's Queen's*. Kingston: Alumni
Association of Queen's University, 1977.

Henderson, George. "Fort Henry During the Second World War."
Historic Kingston. Kingston Historical Society, 34:37-55, 1986.

Hughes, J.A. "The Kingston Observatory." *Historic Kingston*.
Kingston Historical Society, 34:99-102, 1986.

"Locomotive Upsets, Two Crewmen Killed in Spectacular Crash
Here." *The Kingston Whig-Standard*. 11 August 1947.

Machar, Agnes Maule. "Some Epochs in the Story of Old Kingston."
Papers and Records. Ontario Historical Society, 8:102-123, 1907.

MacKay, D.S.C. "Kingston Mills, 1783–1830." *Historic Kingston*.
Kingston Historical Society, 25:3-14, 1977.

Moorehead, Earl. "Murney Point: Its Evolution Within a
Civilian/Military Dialectic." *Historic Kingston*. Kingston Historical
Society, 35:64-86, 1987.

New Encyclopaedia Britannica, The. Toronto: Encyclopaedia Britannica Inc. 15th Ed., volume 7.

Osborne, Brian S. and Donald Swainson. *Kingston: Building on the Past.* Westport, Ontario: Butternut Press Inc., 1988.

Patterson, Neil A. "The Building of the Rideau Canal." *Historic Kingston.* Kingston Historical Society, 19:41-55, 1971.

Preston. R.A. "The History of the Port of Kingston." *Historic Kingston.* Kingston Historical Society, 3:3-25, 1954.

Roy, James A. *Kingston, the King's Town.* Toronto: McLelland & Stewart. 1952.

Spurr, John W. "The Night of the Fire, April 17, 1840." *Historic Kingston.* Kingston Historical Society, 18:57-65, 1970.

Spurr, John W. "The Town at Bay: Kingston and the Cholera, 1832 and 1834." *Historic Kingston.* Kingston Historical Society, 23:19-33, 1975.

Stanley, George F.G. "The Battle of the Windmill." *Historic Kingston.* Kingston Historical Society, 3:41-56, 1954.

Stanley, George F.G., and Richard A. Preston. *A Short History of Kingston as a Military and Naval Centre.* Kingston: Department of History, Royal Military College, 1950.

Swainson, Donald. *Garden Island: A Shipping Empire.* Kingston: Marine Museum of the Great Lakes at Kingston, 1980.

Travill, A.A. "Early Medical Co-education and Women's Medical College, Kingston, Ontario: 1880–1894." *Historic Kingston.* Kingston Historical Society, 30:68-89.

Waite, P.B. *The Life and Times of Confederation, 1864–1867: Politics, Newspapers, and the Union of British North America. Toronto:* University of Toronto Press, 1962.

Waldhauer, Erdmute. *Grand Theatre, 1879–1979.* Kingston: Grand Theatre, 1979.